OSCAR DEMEJO

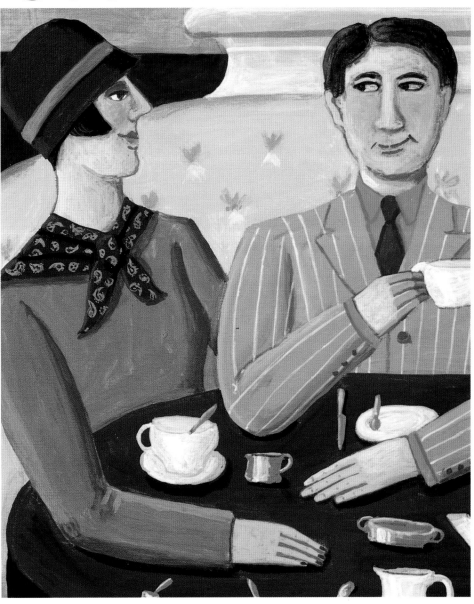

TEA AT THE MAYFAIR REGENT *Detail.*

OMOR, THE EXTRATERRESTRIAL *1985. 11 x 14." Ink. Collection D.K. Pressman.*

Oscar DeMejo
The Naive Surrealist

My Life as an Artist
AUTOBIOGRAPHY
Oscar de Mejo

The Naive Surrealist
ESSAY
Robert C. Morgan

NAHAN GALLERIES
NEW YORK NEW ORLEANS TOKYO

HARRY N. ABRAMS, INC., Publishers, NEW YORK

To my wife, Dorothy, with love.

DESIGNED BY BOB CATO

Library of Congress Catalog Card Number: 91–76381
ISBN 0–8109–3209–1

Copyright © 1992 Nahan Galleries, Inc.,
New Orleans, Louisiana

Published in 1992 by Nahan Galleries, New Orleans,
and Harry N. Abrams, Incorporated, New York,
a Times Mirror Company

Printed and bound in Hong Kong

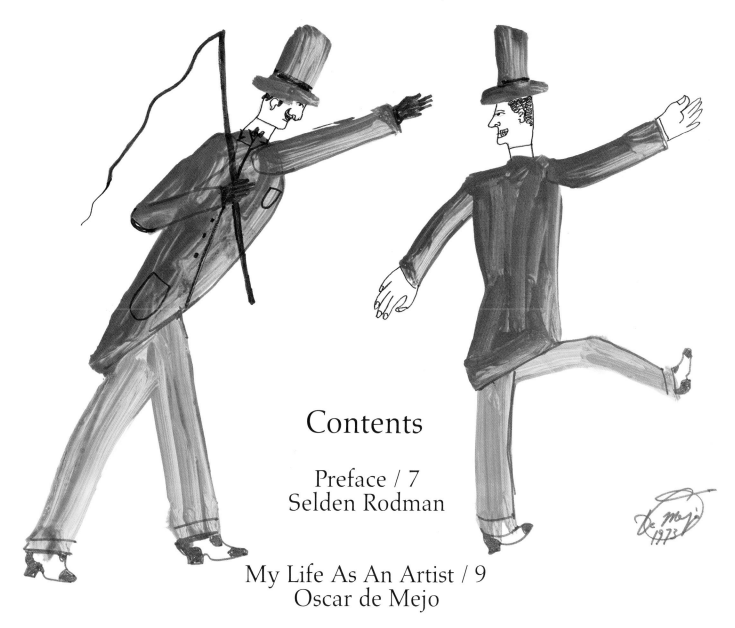

Contents

PREFACE

The art of Oscar de Mejo, the Italian-born painter who has made his home in the United States for many years, is unique in several respects. Brilliantly painted, de Mejo's pictures make no effort to deal with "significant" social themes, or even with the appearances of everyday life. They differ in this from the paintings of such well-known popular artists as Pippin and Fasanella in the United States, Benoit and the Obins in Haiti, Heitor dos Prazeres and José Antonio da Silva in Brazil, whose creations have folk antecedents. But neither does this art have anything in common with such a typical "naive" as Grandma Moses, for de Mejo is not sentimentalizing, or even remembering his childhood. A sophisticated man of the world who has known the art of the museums almost from birth, de Mejo paints like the self-taughts because theirs are the pictures he admires, and he succeeds because his vision of the world is as innocent as theirs. Paradoxical? Perhaps. But the fact is that de Mejo's distortions, extreme juxtapositions of scale, and sense of the preposterous are never at odds with a vision of past and present which views history as consistently comic but always benign. Only a precocious child who has looked closely at the imagery of Sassetta and Piero di Cosimo, de Chirico and Rousseau, could approximate these seductive scenarios – but such a child would have to have carried them into adulthood without suspension of belief. With a sense of humor that never "sees through" the myths of the history books, de Mejo is able to re-create the battles of the American Revolution, the deeds of the Founding Fathers, and even the portentous encounters of today's corporate bigwigs with all the unblinking delight of a gifted kid to whom the pageantry is the ultimate reality – and absurdity.

SELDEN RODMAN

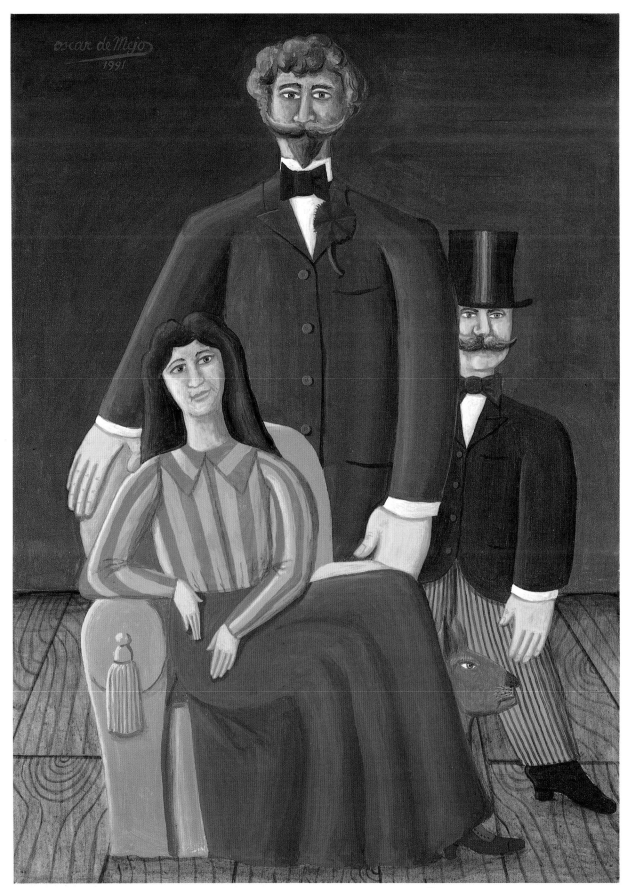

THE INTRUDER *1991. Canvas, 36 x 26″.*

My Life
As an Artist

Oscar de Mejo

A recent portrait taken by J.T. Sander
in my New York studio.

A 1917 portrait taken in Bologna.

The first "work of art" I created was the drawing
of a train on a page of a precious German encyclopedia.
My parents could not punish me for this literary faux pas
because I was only three years old!

I was born in Trieste when that city was still the great
port of the Austro-Hungarian Empire. My family was Italian,
from Cadore. At the start of World War I, my father was taken
prisoner in Vienna, and my mother and I took refuge in Bologna
for the duration. I was always attracted by art, and my favorite
book in Bologna was *Pinocchio* in a beautiful color edition
illustrated by Attilio Mussino.

In the early twenties, back in Trieste, which had now
become Italian, I studied at the Ginnasio Liceo Dante
Alighieri – eight hours a week of Latin, eight of Literature,
five of Ancient Greek, two of History, one of Art. For the Art
class we had a richly illustrated book where my favorite artists
were the Florentine and Sienese primitives – Sassetta, Giotto,
Cimabue, and so forth. A strong feeling of admiration for
popular art followed me through my life up to the present day.

At home I was exposed to a lot of art, too, because
my father was a collector of local impressionists and owned
a number of valuable pictures. Also in his collection was
a life-size portrait of my mother, who was one of the most
beautiful and well-dressed ladies in Trieste. Painted by Cernivez,
this picture was greatly reminiscent in its elegant style
of the best Boldinis.

9

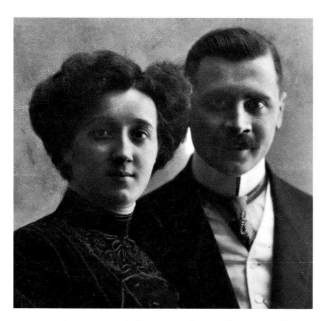

Above: My father, Guido, and my mother, Enrichetta, newly married, in Trieste, 1910. *Below:* In 1928, at the Liceo Francesco Petrarca in Trieste. I am wearing black because my mother had just died.

me

After seeing my favorite cousin, Leonor Fini, become a well-known artist in Italy and Paris, I became aware of a French painter – Le Douanier Rousseau, of whose art I became greatly enamored. There were elements then in my daily life which strongly drew me towards becoming an artist. My tastes in literature went to the comic tales of Wilhelm Bush, the surrealistic novels of Achille Campanile, to the macabre stories of Edgar Allan Poe, Hans Heinz Ewers, and Alfred Kubin. Kubin and Bush were two of my favorite artists along with George Grosz. Of that era I have photos of two paintings of mine, probably executed in the late twenties and inspired by the grotesque tales of Ewers. As a teenager I was always drawing, and I still have several sketchbooks filled with odd illustrations, sometimes funny but often sinister and scary. I believed in ghosts then as I do now and enjoyed tremendously reading stories about vampires and revenants.

My interest in the supernatural has an explanation. When I was eighteen, I lost my mother, for whom I had a real veneration. I desperately tried to find reasons to believe she was not lost forever, and I read many books which gave me encouragement. One of them, called *Towards the Stars,* was the story of a man who had lost his only son in World War I but had found him again through seances. My grandmother and I decided to try and contact my dead mother. It was an unforgettable experience. In the eerie light of a candle, the little three-legged table we were using moved and jumped as if it had a life of its own. We were certain it was my beloved mother. With tears streaming down her face, my grandmother asked, "Do you still love us, Enrichetta?" and the table kept jumping at us in bursts of uncontrollable love.

Around this time something radically distracted me from the field of visual arts – jazz. I started learning to play the piano by listening to the performances of Fats Waller, Art Tatum, Duke Ellington, Mary Lou Williams and, later on, Teddy Wilson. In fact, Wilson became my favorite jazz performer. I started to compose music from an entirely American point of view, and the result was compositions so unusual they got the attention of movie director and matinee idol Vittorio De Sica, who launched me as a composer in the Italian popular-music field. A song of mine was recorded by the most popular jazz band in Italy, the orchestra of Gorni Kramer, featuring pianist Ezio Levi. In a piano duet with my friend Levi, I performed at the Teatro Lirico in Milan. It was a benefit for the Red Cross attended by more than 2,000 people.

During World War II, I was kept out of the military service by a slight heart imperfection, and having always been against the Fascist regime, I had to keep a low profile. I remember the day when Mussolini grotesquely declared war on England and the United States. Corteges of people surged through the streets. They were going to the square to listen to Il Duce's speech. They were full of jingoistic spirit and proudly carried placards with slogans such as "Il Duce Is Always Right," and "Long Live the Rome-Berlin Axis." Later, I saw the same crowd coming back after the

SELF-PORTRAIT *1988. Canvas, 50 x 36". Collection of the artist.*

Jam session with local musicians in
Trieste in 1937.

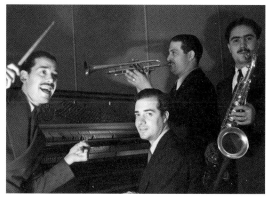

My son Larry in 1974 at the University
of Massachusetts.

Alida Valli in a scene from Hitchcock's
The Paradine Case.

speech completely deflated, dragging behind them their patriotic placards, in the most somber mood. They were going home–to face war!

At the end of the war I became a successful songwriter and married movie star Alida Valli, but still I never dreamed that someday I would become a painter. I followed my wife to Hollywood, where she had been signed by David O. Selznick to play the lead in Hitchcock's picture, *The Paradine Case.* Optimistically, I was expecting to have my own little triumph, but after a partially successful try I reverted to my first love – painting. I realized that the handicap of not being able to write the lyrics of my own songs, which was half my success in Italy, could not be overcome except after long years of studying English.

I remember a couple of episodes from my Hollywood days as a jazz composer. I was with my wife at one of Sir Charles Mendl's parties, and someone asked me to sit at the piano and play "O Sole Mio." My repertoire was of course quite different. I sat down and played "I Can't Believe That You're in Love with Me." I got a big applause, and one of the gentlemen present came to congratulate me with particular emphasis. It was Jimmy McHugh. Unknowingly I had just played one of his songs.

One day Lady Sylvia Ashley called. She and Ida Lupino were fans of mine because of my jazz compositions. She wanted me to meet a songwriter friend of hers so he could hear some of my songs. Lady Ashley and I drove to 416 North Rockingham Drive in Bel Air. I remember a very proper butler opening the door and escorting us into a beautiful living room with wall-to-wall carpeting that resembled green grass. A huge Steinway was in the center of the room. A diminutive gentleman came to greet us. "This is Oscar de Mejo," said Lady Ashley, introducing me, "and this is Cole Porter." A thrilling moment in my life. Since my childhood Cole Porter and George Gershwin had been idols of mine.

It was in 1949 that I decided to go back to my original love for painting. I bought tempera colors and tablets of masonite and started to work. After a week I was far from unhappy with the results. The subjects of my paintings were unusual. They were picked not from real life but from the recesses of my mind. They were indeed memories of things past but sifted through my inner consciousness – a wedding, the first day in school, a battle scene, a fat boat with an odd-looking captain at the wheel, a street scene with pedestrians, and a woman suspended in midair, and so on. The scenes always had something peculiar happening. Little animals, a dog or a cat, were always present as onlookers.

Only six months later, I had my first one-man show at the Taylor Galleries in the Beverly Hills Hotel. It was well received, and one third of the pictures was sold. One little episode comes to my mind. Seventeen-year-old Elizabeth Taylor, whose father owned the gallery, came for the show. She was

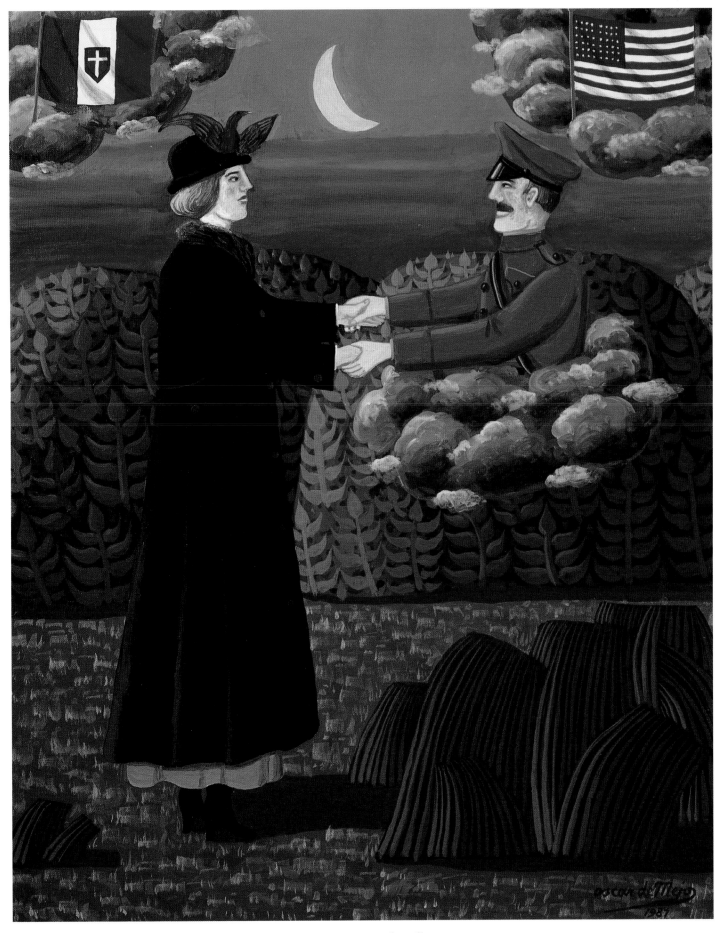

IRREDENTA *1987. Canvas, 28 x 22". Collection Ermanno Mori.*

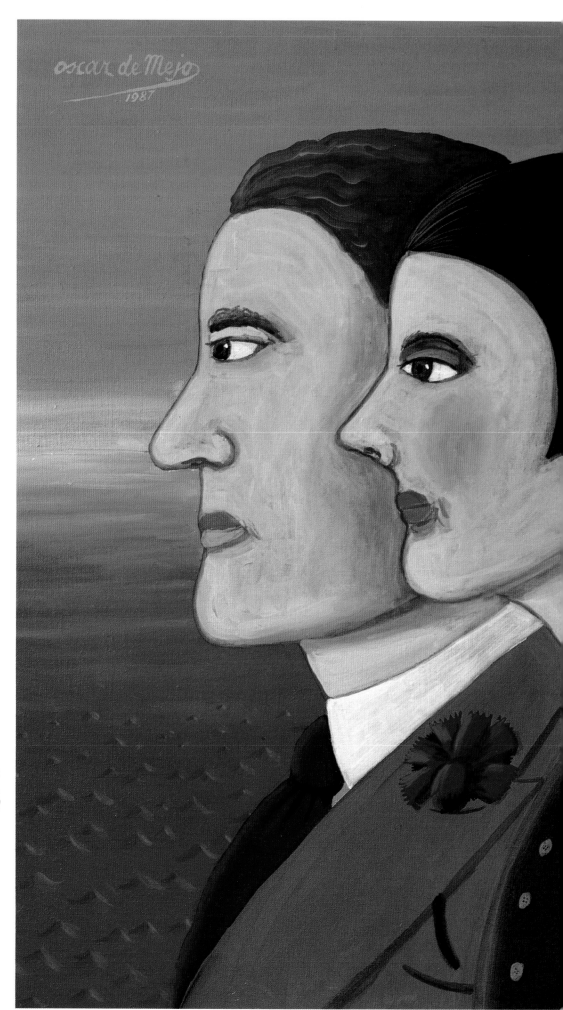

AMERICANS ON THE ILE DE FRANCE
1987. Canvas, 24 x 36".
(See commentary page 136.)

14

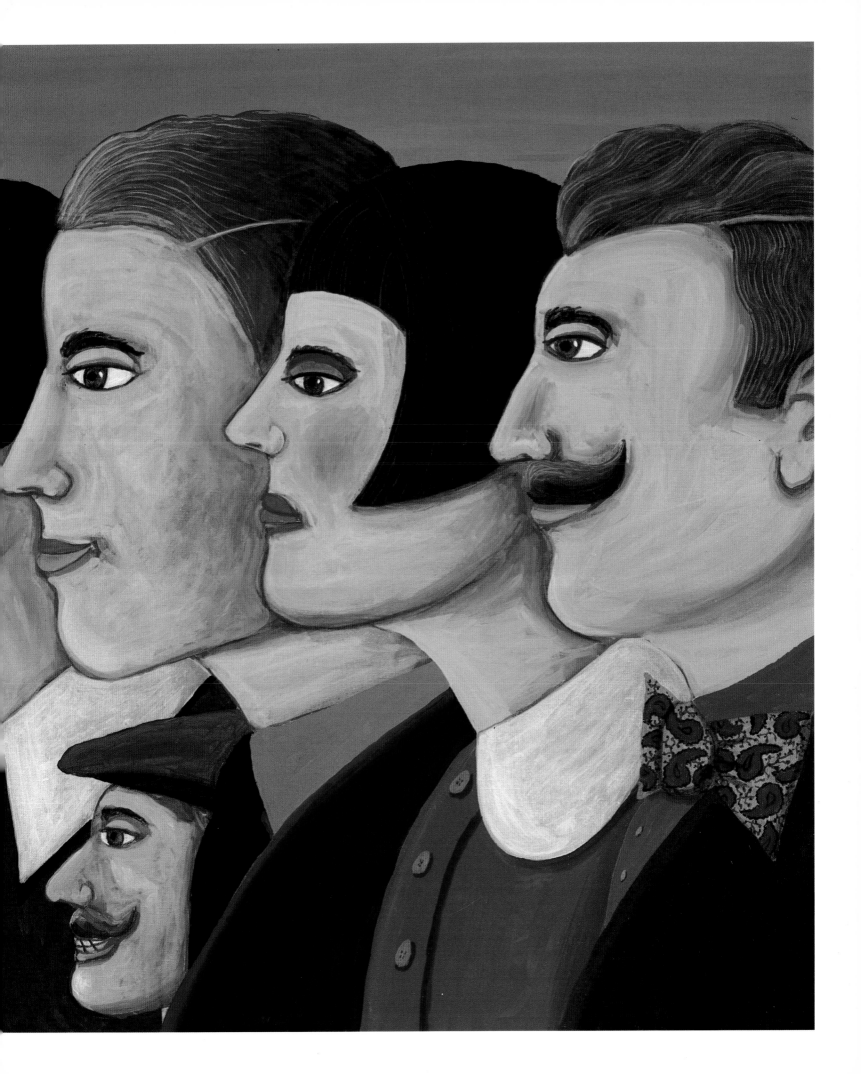

already a big star after her triumph in *National Velvet,* yet she did not mind serving the hors d'oeuvres and drinks to the invited guests. Unexpected successes followed, with the Museum of Santa Barbara giving me a show and the Palace of the Legion of Honor in San Francisco presenting my paintings in a one-man exhibition. I was pleased to be noticed for my own merit rather than because I was the husband of a famous movie star.

Not long thereafter I was engaged by a movie producer, Irving Allen, to do a series of paintings for his picture *New Mexico,* starring Lew Ayres and Marilyn Maxwell. I spent one month in Gallup, New Mexico, among real Navaho Indians and the actors dressed as U.S. Cavalry officers of the 1860s. Even President Lincoln was there briefly, but I can't remember the name of the actor who impersonated him. I made all kinds of sketches, which I later used for the series of scenes I painted

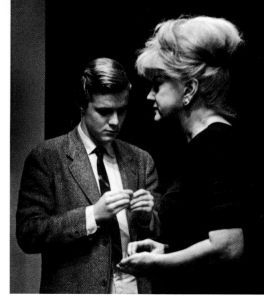

My son Carlo in New York in 1965 with Stella Adler, his drama coach.

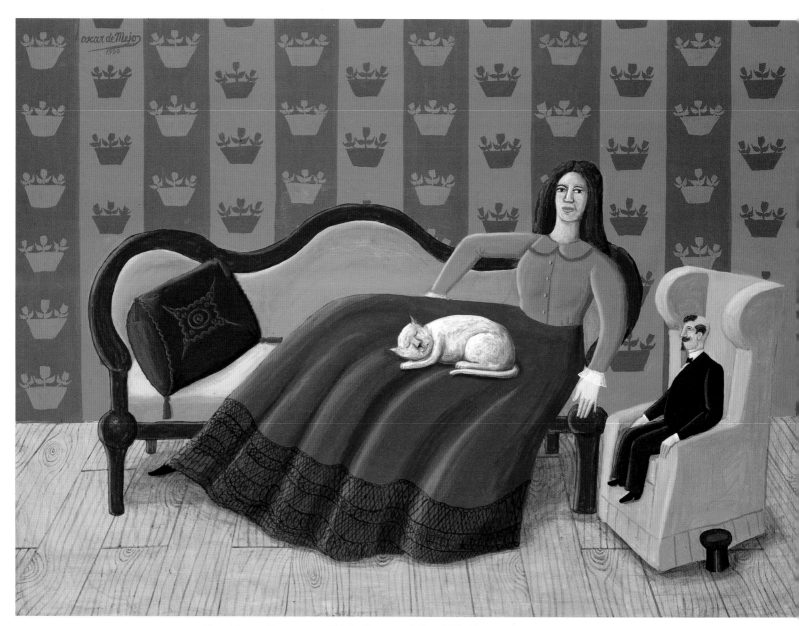

THE TINY SUITOR *1990. Canvas, 36 x 40". (See commentary page 136.)*

about the Civil War. This interesting experience brought me in contact with America of the days of the Western frontier. I saw the wild beauty of the territories where the Indians, Navahos mostly, lived on the mesas. The little towns still had the general stores where cowboys and Indians went to buy oil lamps, moccasins, blue jeans, and the provisions of another era.

In 1949 I took a trip from Hollywood to Paris–three days and two nights on the Super Chief to New York, and then on the *Queen Mary* to Cherbourg, a long but pleasant trip with blinis and caviar every night but also a little seasickness. In Paris, the Galerie Romi at Rue de Seine was going to give me a show, and at the Hotel Pont Royal in Rue du Bac I was painting steadily to complete the number of pictures needed for the exhibition. The hotel was ancient but comfortable–and fashionable because Sartre had lived there for years. The show at Galerie Romi went well, and I had the pleasure of seeing a number of celebrities at the opening–Anatole Jakovsky, the dean of the Paris critics for "primitive" art, came, as did Elsa Schiaparelli, Sophie Pignatelli Sturgess, Leonor Fini, and many others. One painting, *Le Bal Nègre*, was sold to Baron Max Fould-Springer, a relative of Marcel Proust.

In the same year, back in America, I had a show in New York at the Carlebach Gallery on Third Avenue. My show followed the first presentation to the world of Haitian popular paintings. Selden Rodman, who had been responsible with DeWitt Peters for the renaissance of Haitian art and had written a book about it, was in charge of the wonderful Haitian exhibition. I met Selden, and when he saw my work he decided to present it in New York. I was flattered to follow my great colleagues from Haiti whose style was reminiscent of mine. At the opening of my show a number of personalities in different fields made their appearance: Burgess Meredith; the beautiful model Gloria Stavers; Bill Blass, who bought a painting of a battle scene; Leo Castelli; and many others. Howard Dietz, the composer of "Dancing in the Dark," who was then a vice-president of Metro-Goldwyn-Mayer and quite a fan of my work, bought fifteen pictures and commissioned me to do a screen for one of his rooms at his house on West Eleventh Street in Manhattan. He called that room "The de Mejo Room."

The *New York Times* did not ignore my show. On October 7, 1949, Stuart Preston wrote: "Oscar de Mejo's 'primitives' at the Haitian Art Center are deceptive. They seem artless little depictions of street life until a second look discovers the wit and malice that inform this artist's observation. So they can be approached in two ways, enjoyed as ingenuous, bright-colored scenes or relished as hyper-subtle comments on homo sapiens." As well as the review in the *Times,* Dorothy Schiff, publisher of the *New York Post,* gave me a wonderful article in that newspaper.

With the money I made at the show I bought two Haitian paintings from Carlebach–a Hyppolite representing the Haitian

As a law student in Florence, 1932, attending an outdoor party with *(from left)* Vivian Dixon Wanamaker, the granddaughter of New York philanthropist Isidore Straus; Simonetta Corsini; and Alix Nagel.

John W. Kluge, chairman of Metromedia, and his son, John II.

Myself playing the part of a British officer in a 1945 movie that starred Anna Magnani.

17

God Damballah, and another by Micius Stephane depicting
the Marassa Twins, two popular Gods in the Voodoo pantheon.
I chose well.

In 1953 my marriage came to an expected end. My wife
returned to Italy with our two children, Carlo and Larry,
and I stayed in America, leaving Hollywood for my beloved
New York.

In New York I worked through the years with some
favorable results. Howard Dietz asked me to do a poster
for an MGM musical with Gene Kelly. Alexander Liberman, art
director of *Vogue,* published some of my work in his prestigious
magazine. Art Kane of *Seventeen* commissioned me to do
a painting for one of the stories he published. So did Henry Wolf,
who used several of my pictures in *Esquire.*

At this time an idea came to my mind that I thought could
have for my career as an artist some earth-shaking effects.
I thought of narrating in a series of paintings an imaginary
trip of Jesus to present-day New York. Great hopes were placed
on this project, and eight paintings were produced showing
the Savior in some unusual settings: visiting a school in the
Bronx; attending a wedding in Harlem; dropping in at El
Morocco in Manhattan; talking to Dave Brubeck in front
of the Brill Building; enjoying a Sunday afternoon in Washington
Square; and so forth. Henry Wolf, who was then the art director
of *Esquire,* thought the story was worth an eight-page color
spread in the magazine and had his staff photograph my
paintings. Simultaneously a friend of mine, Mario Arbace,
talked to collector Patrick Lannan about my work, and he
summoned me with my eight pictures to his suite at the Pierre
Hotel. He liked my work and said, "Let me show these pictures
to a priest for permanent display in his church. If he likes them,
I'll buy them." I was in seventh heaven.

With the $5,000 I had asked Patrick Lannan for my eight
paintings, not to mention the upcoming pages in *Esquire,*
I felt I had it made, and rosy dreams of further success filled my
mind. A gallery on the fashionable East Side heard of my *Jesus
Visits New York* and arranged to show the series in a forthcoming
exhibition. I was counting on triumphant results because, as it
is with many artists, my financial situation was far from
prosperous. And then things started to happen. I heard from
Patrick Lannan that his priest found my eight paintings far too
advanced for his church. A visit of the Savior to El Morocco!

Shocking. And so the sale was out. Then I got a call from *Esquire.* One of the new editors, Clay Felker, had killed the story – too controversial for *Esquire* readers. To top it all, my gallery opened the show with a great success in public interest but…no sales. New York was ten years away from *Jesus Christ Superstar.*

The shock of my debacle was quite traumatic. I stopped painting for a long time, and when I resumed it was as a Sunday painter. Instead I worked in the field of publicity. Finally I had a steady income and could make ends meet, but I sincerely missed painting.

God works in mysterious ways. The eight paintings on the story of Jesus went to Ermanno Mori in Italy, who gave me,

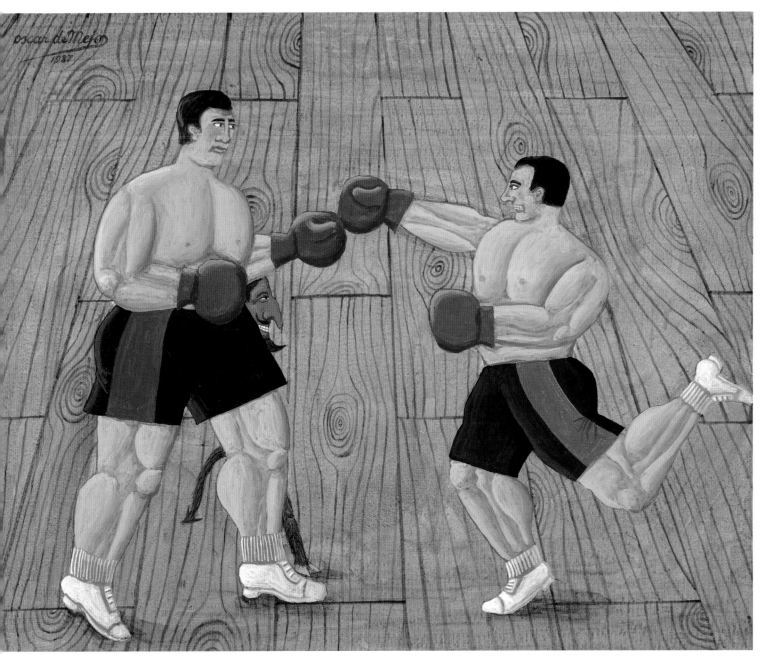

THE CHAMPS *1987. Canvas, 22 x 28". (See commentary page 136.)*

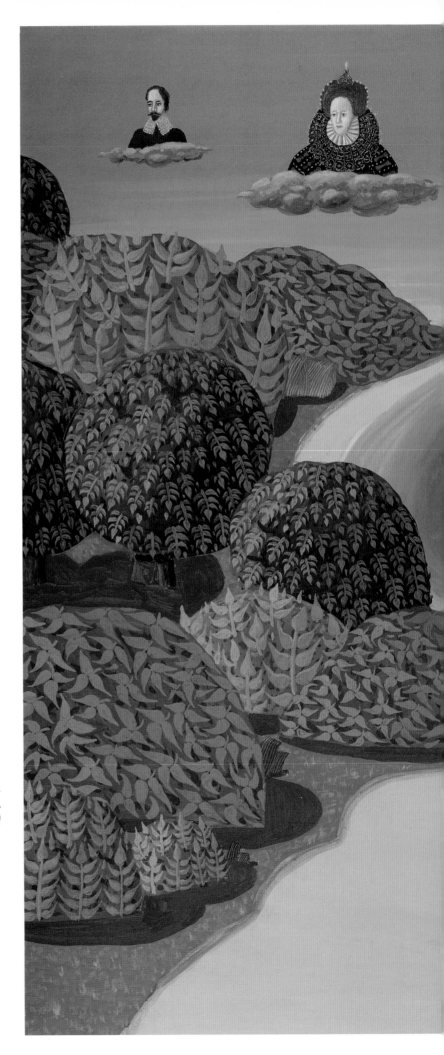

I'LL CALL THIS LAND VIRGINIA
1985. Canvas, 38 x 48". Collection John W. Kluge.
(See commentary page 136.)

20

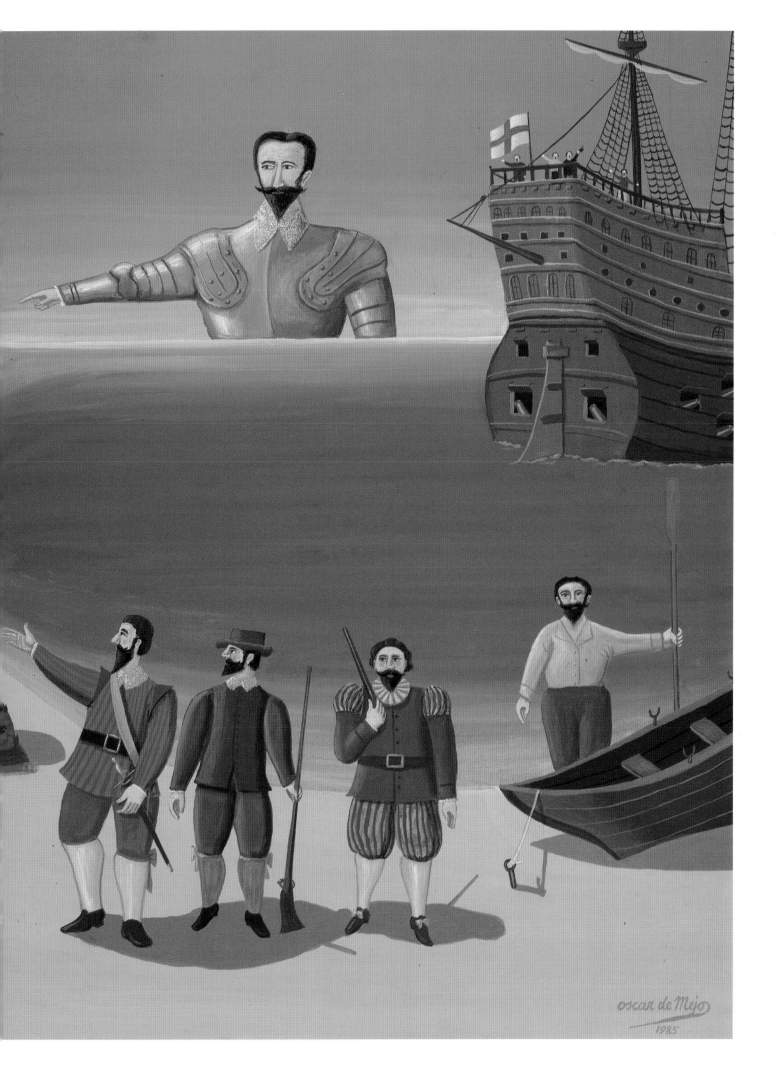

oscar de Mejo
1985

With my wife, Dorothy, in 1968.

as an exchange, a beautiful house on one of his properties in Le Marche. Mori is a connoisseur of folk art; he is the number-one collector of votive paintings in the world, owning over three thousand of them. These votive tablets are now in a museum built by him in Civitanova Marche, while my series of paintings on Jesus in New York are displayed in his home.

In the sixties my philosophy of life was conditioned by reading the books of Yogi Ramacharaka and discovering the *I Ching.* Yogi Ramacharaka was an Indian philosopher who lived around the turn of the century. His lectures, collected by the Yogi Society of Chicago, were revealing reading for me. They gave me peace of mind, and because of the logic and wisdom in them about things human, they made me look at each day with new understanding and acceptance.

The *I Ching* was presented to me by some friends who told me, "If you have a problem, consult the *I Ching* and it will help you solve it." I was immediately interested and respectful because the book has been an unfailing oracle in China for millennia. In addition, Carl Gustav Jung had written the wonderful preface.

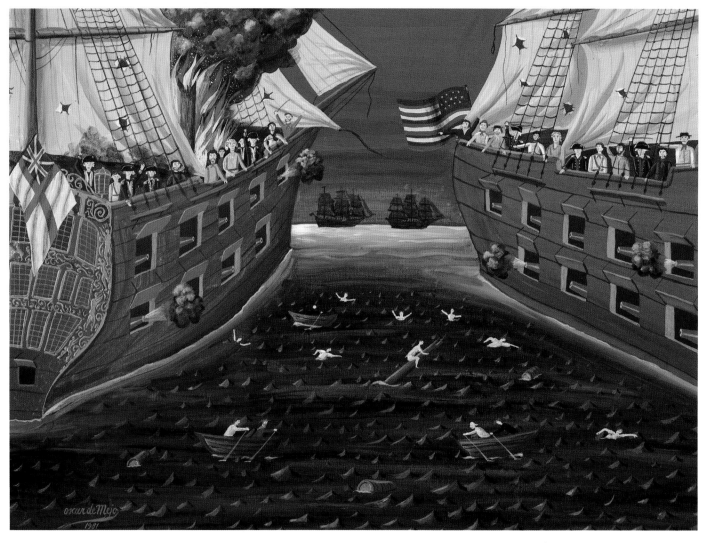

CAPTURE OF THE H.M.S. SERAPIS *1981. Canvas, 18 x 24". Aberbach Fine Art.*

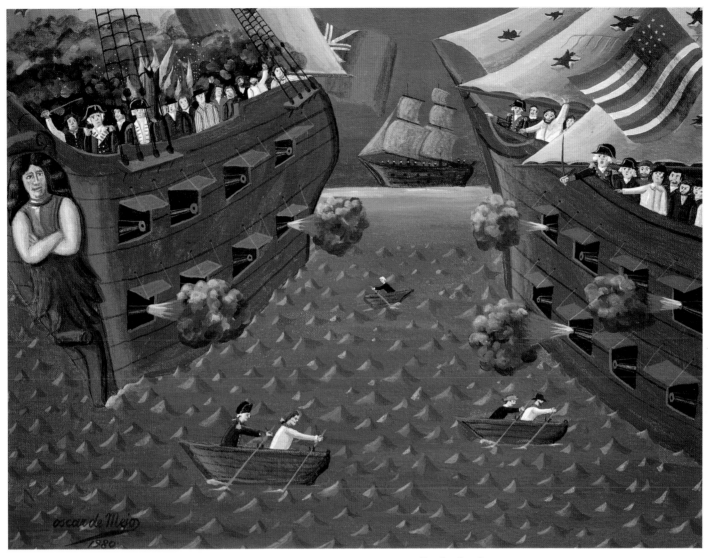

NAVAL BATTLE *1981. Canvas, 26 x 36". Aberbach Fine Art.*

It turned out that for me the *I Ching* was a revelation. It answered my questions with uncanny accuracy. I have continued to consult the book, but only when I desire an answer to a problem I cannot solve myself. The answer always comes; sometimes it is obscure, but mostly stunningly clear.

In 1967 I married again. My new wife was Dorothy Graham, whom I had known for some years. She was a modern dancer of great talent who understood and admired my work. When I decided to marry her I knew I was stopping a promising career in dancing, and for that I am remorseful but grateful.

At that time I took another momentous step – I decided to leave my work in publicity and dedicate my whole time to painting. The decision coincided with an offer of a contract by two industrialists from Milan to go to Italy and paint for them for a whole year. The financial arrangement was very good, and so I accepted. Besides, I wanted to go to Italy to remodel

the fourteenth-century house I had received from my friend Mori. Perhaps I would settle in Italy for good.

In Milan we stayed at the Residence Maria Theresa, where I started to paint almost immediately. Beniamino Levi, who owned one of the top art galleries in Milan's Via Montenapoleone, had offered to give me an exhibition in six months. I had spent time viewing nineteenth-century renditions of Napoleonic battles created by the French Imagerie d'Epinal, and my imagination was populated by French Cuirassiers and British Highlanders, and so I started a series of paintings on the Battle of Waterloo. The beautiful uniforms of the French and British armies intrigued me to the point that the results in my paintings of battle scenes were always an array of handsome men in magnificent uniforms in a bloodless *tableau vivant.* One of my two sponsors, Elio Mottura, took a liking to the first picture in the series and hung it in his villa at St. Tropez. "Brigitte Bardot loves it," he reported.

Above: At the Goldwyn Studio in Hollywood in 1950 with five jazz greats: *(from left)* Benny Goodman, Charlie Barnet, Louis Armstrong, Lionel Hampton, and Tommy Dorsey. *Below:* My cousin Leonor Fini with one of her seventeen cats.

The day of the show at the Levi Gallery came, and the exhibition displayed a number of my pictures representing not only Napoleon and his battles but also a variety of subjects such as snow landscapes in Cortina and beach scenes in Capri. A great success was a portrait of the Hotel Miramonti with the snow-covered Dolomites in the background. Many people of the *Milano bene* came to see the show. Dino Buzzati, an artist himself and a writer whom I greatly admired, gave the show an excellent review in the *Corriere Della Sera.* The nice words I heard from the top art critic in Italy, Gillo Dorfles, were also sweet music to my ears. I was a friend of Dorfles from childhood, as we were both born in Trieste, but his words seemed completely sincere and unbiased in his praise.

Following my Milan exhibition, our time was divided between Milan and Le Marche, where our beautiful fourteenth-century house was being fitted with a heating system, storm windows, and modern appliances. As soon as the work was finished, we left Milan and moved to Le Marche, where I continued to paint the required pictures for my sponsors.

We stayed two years in Italy, enjoying our new friends and an uneventful life in the country. We had also an apartment in Milan, where we had to be from time to time for business reasons. All the major publications, such as *Europeo,* Mondadori's *Grazia,* and Rizzoli's *Oggi,* gave me a lot of attention. I had come back to Italy for good, they said, but it was not so. Deep inside of me there was a yearning growing stronger every day for my beloved New York. My wife felt the same way, and so the day came when we closed our beautiful house in Le Marche and went to Milan to board a U.S.-bound plane. Before our departure, publisher Franco Maria Ricci gave me a show in his prestigious Gallery of the Bibliophiles at Via Bigli. It was like Italy's farewell party for one of her prodigal sons who was leaving her again for mythical America.

In New York we stayed at the Adams, a little hotel on East

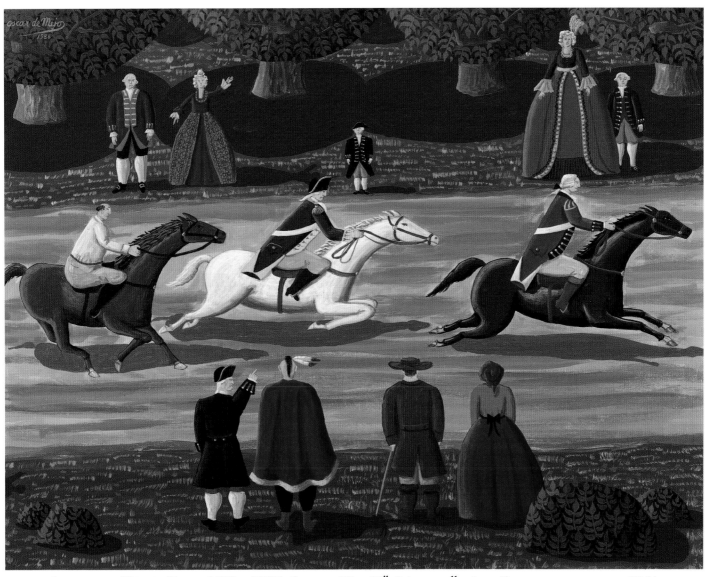

AMERICAN HORSE RACE, 1783 *1988. Canvas, 30 x 40". Private collection. (See commentary page 136.)*

Critic and art historian Robert Morgan.

Eighty-sixth Street, happy to be once more in that big city. Our joy, however, was constrained by lack of money. I was starting once more my American adventure, and I was starting from scratch. The Latin proverb says *Audentes fortuna iuvat;* if Lady Luck ever helped the daring soul she had to be moved by my personal case.

I had to sell paintings. Some interesting ideas were taking shape in my head. Friends and collectors from Philadelphia gave a cocktail party for me, and I was able to show some new pictures and sell a number of them. It was a shot in the arm. Alec Alexander, a friend of Selden Rodman, was a great admirer of my work and for years a collector of my pictures. I made a proposal to him – to do the story of Philadelphia in a series of twelve paintings. He loved the idea, and I signed a contract with him and his business partner Jack Wolgin, a builder. But when Wolgin saw my first picture of the series, *The Founding*

25

THE MIRAGE *1989. Canvas, 30 x 40″. Collection Perla Slimak. (See commentary page 136.)*

of Philadelphia, with William Penn purchasing the land from the Indians, he thought that the Indians were too fat and turned down the picture and the whole idea of the series. The Indians were indeed pretty well fed, but I had painted them that way only to show the fertility of the land.

The idea to sell not just a single painting but a whole series stayed with me. Why not do, for instance, the story of America? I called up a friend, Lydia Silvani, who was working at the Interpublic Group of Companies, and asked her if she could arrange for me to see her boss, board chairman Paul Foley. Paul was a wonderful person, a man of great vision. He listened to me propose my plan and told me he was going to think it over. Two weeks later he called and suggested, "Why not do for us the story of the American Revolution." We were three years away from the Bicentennial celebrations. I accepted the offer with great enthusiasm, plunging immediately into a concentrated study of American history.

Studying American history was a peculiar experience for me: it was like going back to an old past, a personal past. Reading about certain battles awakened in me strange recollections of experiences from long ago. With my background in yogic philosophy, it was not surprising that I should ask myself, "Was I there in a previous life?" In specific, the South during the years of the Civil War came back to me with disturbing clarity. Slowly an image surfaced in my daydreaming: I had been a soldier fighting for the South but my sympathies lay with the Northern cause. Ironically, I had died on the battlefield at the hands of my spiritual friends, the Yankees.

From experience I have learned to keep such thoughts to myself. I was having lunch with a lovely Hollywood star and imprudently told her, "I think I have met you before. Could it have been in the South? I was a soldier there in 1863 fighting for the Confederacy…." Sometime later another actor, who like me believes in reincarnation, said, "You should be more careful when talking about these matters with nonbelievers. There is an actress in Hollywood who is making fun of you, saying you claim to have been a Confederate soldier in a former life."

It is true that nothing succeeds like success. Shortly after signing my contract with Interpublic, I received an offer from Bob Guccione to do twenty-five paintings on the history of America. Bob, an extremely likeable gentleman, is of course the publisher of a very successful if controversial magazine, but he is also a very serious collector of art. Not only does he own paintings by old masters such as Botticelli and Caracci but also some outstanding work by moderns such as Chagall, Renoir, Degas, Picasso, Matisse, Roualt, and Modigliani.

With Vittorio De Sica *(center)* and Ezio Levi *(foreground)* after a recording session for Columbia Records in Milan in 1936.

Lydia and Paul Foley. As chairman of the Interpublic Group of companies, Paul commissioned me to do the story of the American Revolution.

Yet one more commission came to me from Belgium. The Merck Sharp and Dohme Company was opening their European headquarters there, and they bought an old idea of mine – to do a series of paintings that would tell the story of that pharmaceutical company. The paintings would be exhibited permanently in the hall of the new building to tell the public how a little family pharmacy in fifteenth-century Germany had grown into a huge business empire.

When 1976 arrived, Rizzoli came out with *Fresh Views of the American Revolution*, a beautiful art book written by Paul Foley. It was a modern study of the "world turned upside down" with most interesting evaluations of events and characters of that period. Fifteen of my paintings in glorious color illustrated the book. I was indeed very happy. At the suggestion of Paul Foley, Tom Armstrong, director of the Whitney Museum of American Art, gave my series of paintings a private showing. The exhibition was a short one but, as Armstrong said, it was still a tribute to the artist.

Following a recommendation by Armstrong to Daniel Hawks, Curator of the Virginia Independence Bicentennial Commission, I had a group of important exhibitions in the South. One was held in Williamsburg at the Botetourt Gallery of the College of William and Mary, another at the Yorktown Victory Center in Virginia in connection with a show called "The Folk Artist Looks at the American Revolution."

A friend who is an art critic wrote an essay about my work and submitted it to an editor at an art magazine. When he was told that Rizzoli had just published a book with fourteen of my historical paintings illustrating the text, the editor frowned. He said he was not interested in running a story about an illustrator, and that was the end of that. Without commenting on this particular incident, I would like to remark on the attitude many people in the art world have toward illustrators, who are considered to be far inferior to the so-called "fine" artists. This really saddens me; only ignorance brings about this preposterous evaluation.

At that moment of my career I was longingly searching for a good dealer who would take care of shows and the selling of my work, and someone came along – Jean Aberbach. I highly respected his gallery, which to a certain extent had resisted the enticements of the avant-garde and had concentrated on traditional and more solid forms of art. In this case traditional did not mean passé. Artists that Jean Aberbach collected were of the caliber of Delvaux, Hundertwasser, Grau, and Botero. I was indeed flattered when Jean said, "Start painting for us, we'll sign a contract with you."

Another happy event took place in my life. Judging that the time had come to boost the work of contemporary folk artists in America, I went to see Roger Straus, a well-known New York publisher, with the suggestion that he do a book on current folk artists in America. He directed me to Paul Gottlieb, who

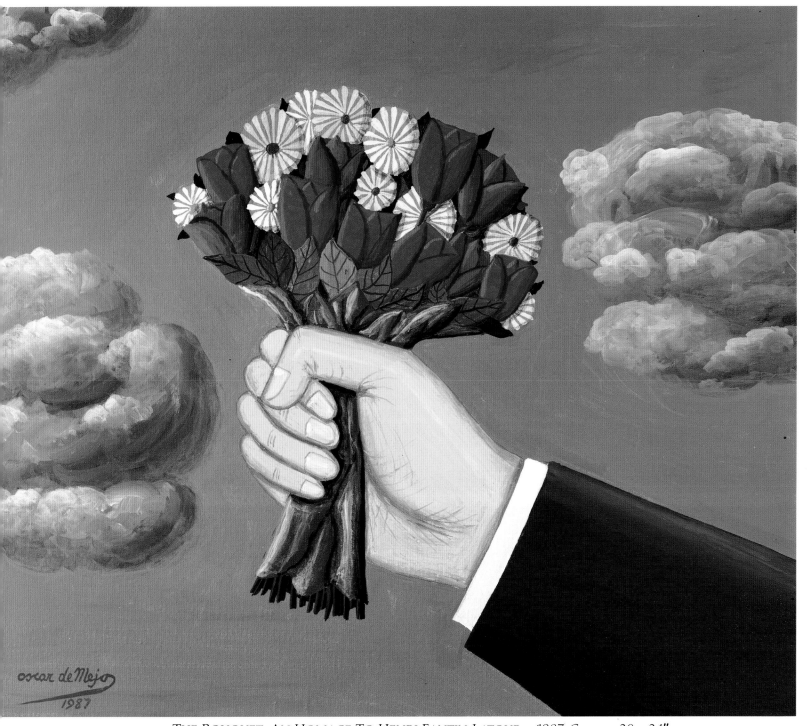

THE BOUQUET: AN HOMAGE TO HENRI FANTIN-LATOUR *1987. Canvas, 20 x 24".*

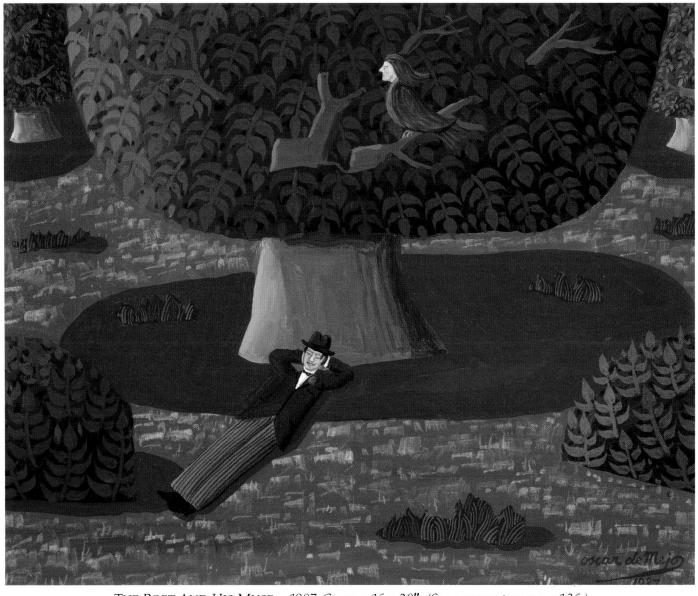

THE POET AND HIS MUSE *1987. Canvas, 16 x 20". (See commentary page 136.)*

heads the prestigious art publishing concern of Harry N. Abrams, Inc. Armed with my strong beliefs and carrying with me color transparencies of my work as well as that of several colleagues whom I admired, I went to see Gottlieb. With his background as an editor of *American Heritage,* Gottlieb was quite in tune with what I was proposing. "Let me think about it," he said, and I knew that he meant it. A couple of months went by and then the phone call came. Would I go see Mr. Gottlieb? I was thrilled. I went to Abrams filled with hope and was shown into Gottlieb's office promptly. Also there was Margaret Kaplan, one of the chief officers of the company. "We have discussed your idea," said Gottlieb, "and we decided that rather than a book on popular artists, we would like to do a book about you and your work." I think any comment here is superfluous. I was naturally sorry for my colleagues, but I was delighted and confess it.

My contract with Aberbach lasted two years and then was renewed for another two. Some of my best pictures on American history were produced in that period and are now owned by Jean Aberbach. When my contract came to an end I received an important new commission from John W. Kluge to do a series of twelve paintings on the history of Virginia. Kluge lives in Charlottesville, and at that time was building a fabulous mansion – Albemarle House. I had already done some work for Kluge back in the seventies when he commissioned me to do fifteen paintings on the story of the Harlem Globetrotters.

Meanwhile an art dealer from New Orleans decided to sign me up. I had known Kenneth Nahan for many years and had always appreciated both his abilities as a dealer of art and his

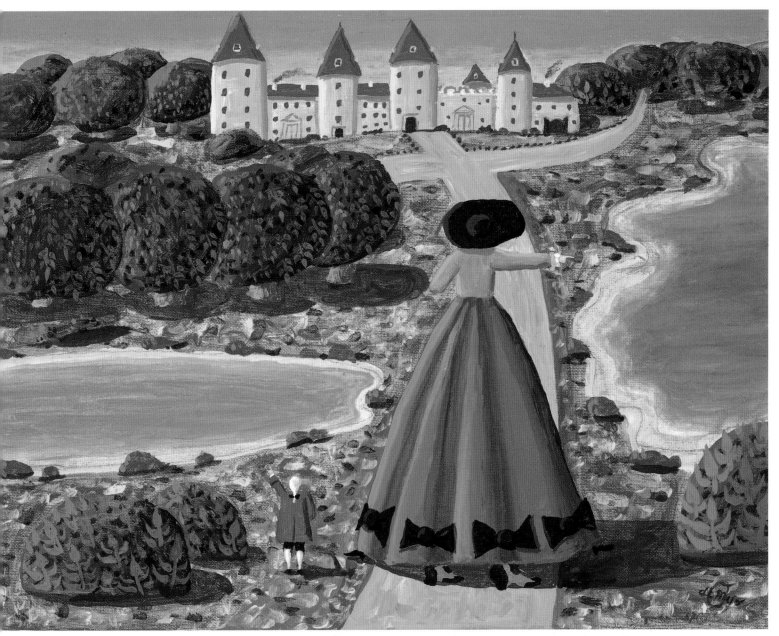

THE TWO LAKES *1990. Canvas, 12 x 15". From the book,* La Bella Magellona and the Little Cavalier.

Artists of the Nahan Galleries: *(counterclockwise, bottom left)* Max Papart, Kenneth Nahan, Sherri Nahan, Theo Tobiasse, Oscar de Mejo, Arthur Secunda, Nissan Engel, Beatrice Kohn, Robert Dutrou.

personal qualities as a gentleman and a gentle man. He really believed in my art, and this was the main reason why I signed with him. He arranged for me to have a show in New Orleans and invited me and my wife to be present at the opening. We stayed in a plush hotel in the French Quarter and immediately fell in love with the city. The name of New Orleans had been very much part of my life in the past. I had heard from my mother the story of one of her ancestors who in 1836 had gone from Trieste to New Orleans and had written a letter to the family announcing his arrival in the New World. That letter had been the first and the last received by my family; the young traveler disappeared, never to be heard from again. Another tie to New Orleans was jazz. Many of the recordings I collected as a teenager in Trieste featured famous jazz orchestras and soloists from that city.

My show opened at the Royal Street Nahan Gallery with a party attended by prominent New Orleanians. City Councilman Michael Early handed me a certificate of merit signed by the Mayor, with the symbolic keys of the city. For the occasion of the show I created two paintings: *The Louisiana Purchase* and *The Battle of New Orleans*. We enjoyed tremendously all New Orleans had to offer, jazz at the Preservation Hall included. The Museum of Art gave a luncheon in my honor where I met John Bullard, the director; Valerie Loupe Olsen, Chief Curator of Collections; and many of their prominent members. After the lunch, on a tour of the museum, I was particularly interested in seeing the original painting of the Battle of New Orleans, painted in 1815 by Jean Hyacinthe de Laclotte, and the latest acquisition of the museum – a portrait of Marie Antoinette by Elisabeth Vigée-Lebrun.

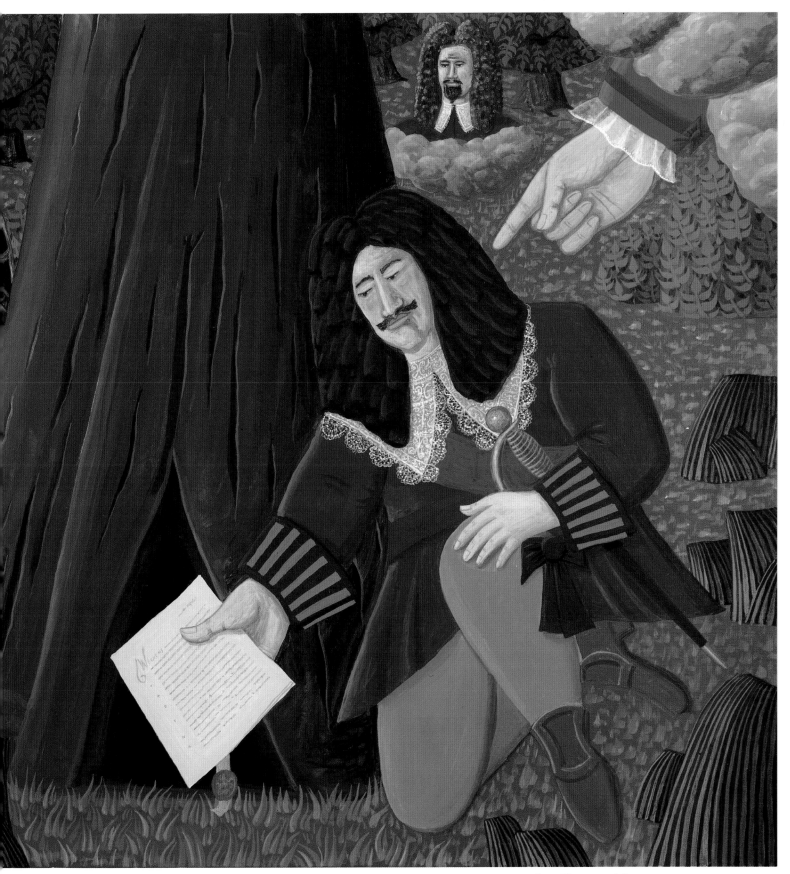

THE LEGEND OF THE CHARTER OAK *1989. Canvas, 36 x 50". Collection of the artist.*

As I have mentioned Marie Antoinette, I would like to explain how I have come to feel connected with that queen in a special way. Ever since I was a teenager, I have had an almost morbid interest in the French Revolution. Again, as with the American Civil War, whenever I read about the events in Paris of 1789, images came to me that were like personal memories. The tragedy of the royal family hit me particularly hard, and the drawing by Jacques Louis David of Marie Antoinette being brought to the scaffold constantly haunted my thoughts. My recollections suggested to me a fantasy: In 1770, I had been a Venetian of means and had spent some time in Paris and Versailles, possibly meeting there a fellow citizen, Giacomo Casanova. Every time I am in Paris I never fail to visit the cell that was the last refuge on earth of the unhappy Marie Antoinette. I am even the proud possessor of an exquisite lace handkerchief that belonged to her. The friend who gave it to me received it from a Polish nobleman whose ancestor had been a diplomat at the Court of Versailles; it had been a gift to the ancestor from the queen herself.

Back in New York I was confronted with quite an amount of work, a situation which made me happy since I never regarded my work as a chore. On one hand I had to prepare my monthly production for Ken Nahan, who made it easy for me by giving me carte blanche as to the subjects of my paintings. On the other hand I was preparing for John W. Kluge the twelve pictures he had commissioned me to do on the history of Virginia. Before starting this project I asked Kluge if I could visit Charlottesville and Monticello, and I spent a few days as his guest in Albemarle County. Mrs. Kluge took me to visit Monticello, where Thomas Jefferson had lived.

Monticello made a great impression on me. I felt as if Thomas Jefferson had lived there until the day before, so haunting was the atmosphere of his home. Back in New York, the subject of my next two paintings was indeed Monticello. The first, *The Hero of Charlottesville,* showed the meeting between Jefferson and Captain Jack Jouett, who had ridden all night to advise the Governor of Virginia of the imminent arrival of the British cavalry. The second painting was *The Charge of the 17th Light Dragoons.* In it I depicted the frantic ride of Banastre Tarleton's Light Dragoons to try and capture Jefferson at Monticello. My technique in doing these and other historical paintings was first to read every possible report by witnesses of the time and then give my pictorial impression of the event.

One of the interesting experiences of my career has been my acquaintance with Hilton Kramer, one of the top art critics in America. Hilton was a friend of Fred Pressburger, a friend of mine. Thus I had a chance of seeing him quite often. One day I even discussed modern art with him. With absolute frankness I told him my theories about modern art. The fact that abstract art had established itself so strongly versus traditional figurative

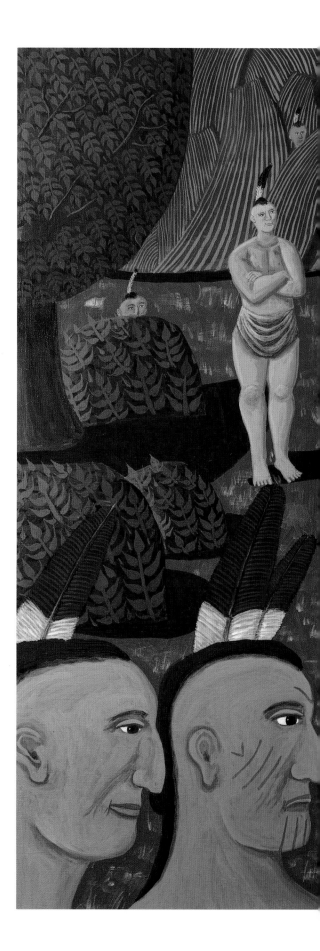

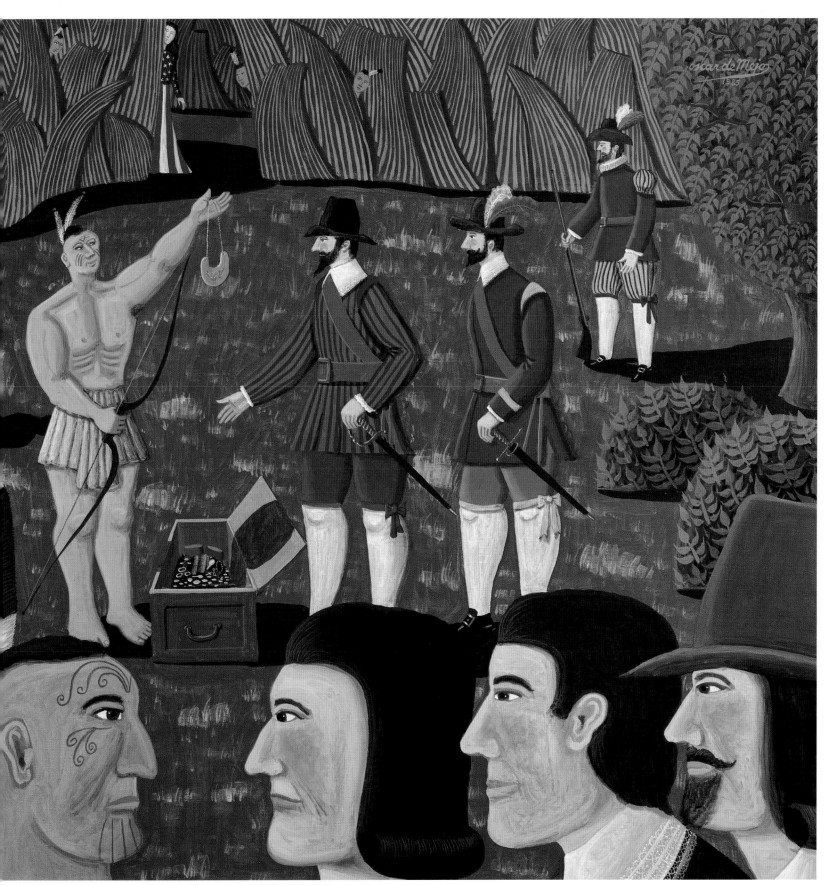

MEETING WITH THE INDIANS *1985. Canvas, 36 x 50". Collection John W. Kluge.*

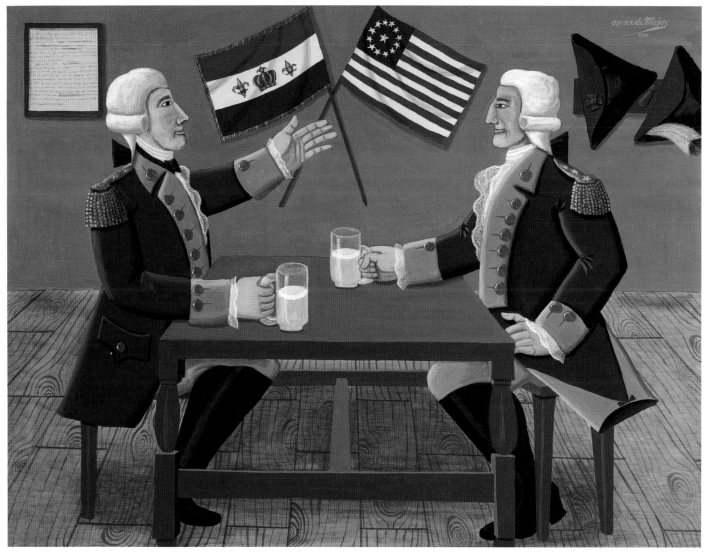

LONG LIVE AMERICA, VIVE LA FRANCE *1986. Canvas, 36 x 40".*

art was, in my estimate, due to the brilliant words of such critics as Harold Rosenberg, Clement Greenberg, and Kramer himself. Their articles in newspapers, magazines, and art books had established the new art as a fad, and nearly everybody had sworn allegiance to it. It was attractive for people to claim they understood abstract art and could see eye to eye with the Rosenbergs, the Greenbergs, and the Kramers. In other words, the new art existed in the brilliant prose of the critics rather than in the work they described. Smiling, Hilton disclaimed my theory, and I believe modesty was one of the reasons why.

There was another critic in Europe whom I admired, although we did not see modern art in similar ways – Gillo Dorfles. Born in Trieste, he went on to become professor of aesthetics at the Universities of Cagliari, Florence, and Milan; lecturer on modern art in Europe and America; and author of a very successful book, *Kitsch, the World of Bad Taste.* He was also known in Europe as the herald of the avant-garde. I was happy to learn that this man, whom I had known all my life, had accepted to write the preface to the book about my art that Harry N. Abrams, Inc., was getting ready to publish.

With my old friend, Hildegarde

36

Meanwhile, Ken Nahan, my art dealer in New Orleans, had been asked by the Contini Galleries in Caracas, Venezuela, to supply a number of my paintings for a show there. Eighteen pictures were sent and the show announced to the public. What happened next was unexpected – the show was sold out even before it opened. I give a lot of credit for this huge success to the owner of the gallery, Ivan Tänzer.

In June, 1986, John and Patricia Kluge made arrangements with the Bayly Museum of the University of Virginia in Charlottesville to have a show of the series depicting the history of Virginia. The Kluges invited me and my wife to be their guests at Albermarle House for the opening of the show, which was attended by around four hundred people. Guests were kind in wanting to meet me and generous in their congratulations. After the show, two friends of the Kluges, Mr. and Mrs. Eric Heiner, gave a dinner in my honor for a number of important

LIBERTY OR DEATH
1986. Canvas, 38 x 48".
Collection John W. Kluge.
(See commentary page 136.)

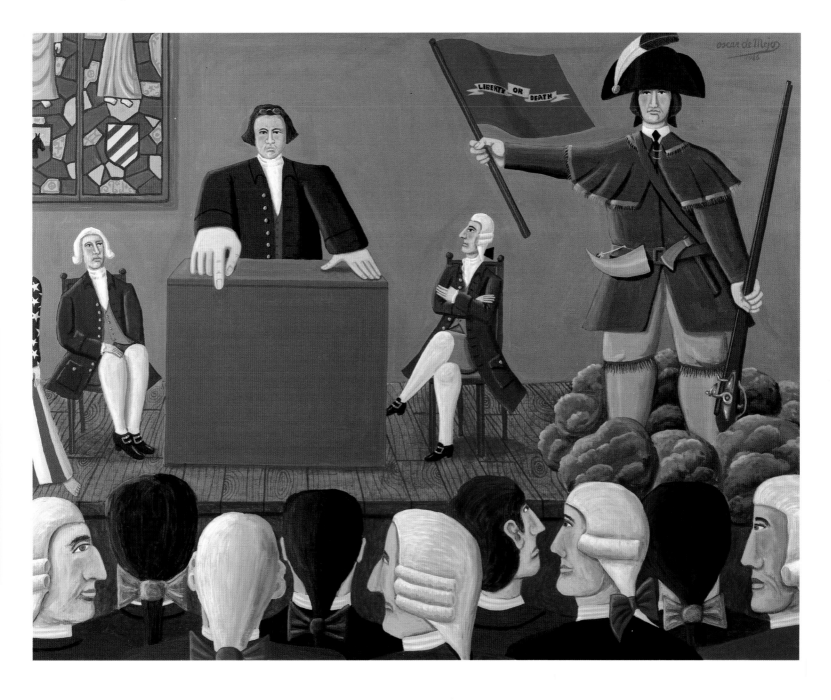

guests, among them David Lawall, the director of the museum. The next morning John Kluge took us back to New York on his private jet.

One day I got a phone call from Giulio di Lorenzo, the Italian Consul General in New York. Knowing that I had done a series of pictures on the Unification of Italy for the Mondadori Company, he asked if he could borrow the series. There were twelve paintings in which Giuseppe Garibaldi, the Italian hero, was prominently featured. The reason for his request, he explained, was that Italian Premier Bettino Craxi was expected shortly in New York. The Premier was a well-known fan of Garibaldi and a collector of his memorabilia, and the Consul

GEORGE WASHINGTON'S INAUGURATION *1988. Canvas, 26 x 34". Collection Marsha and Michael Dayan.*

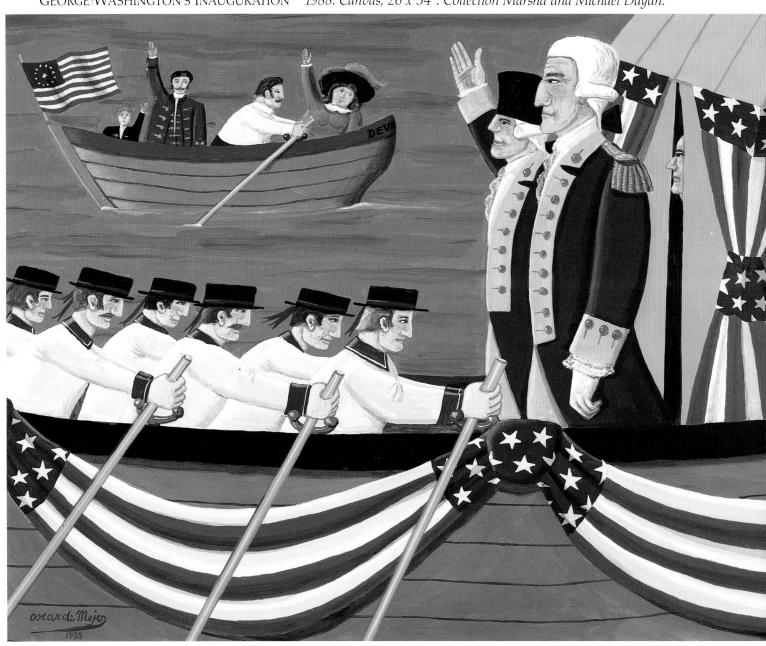

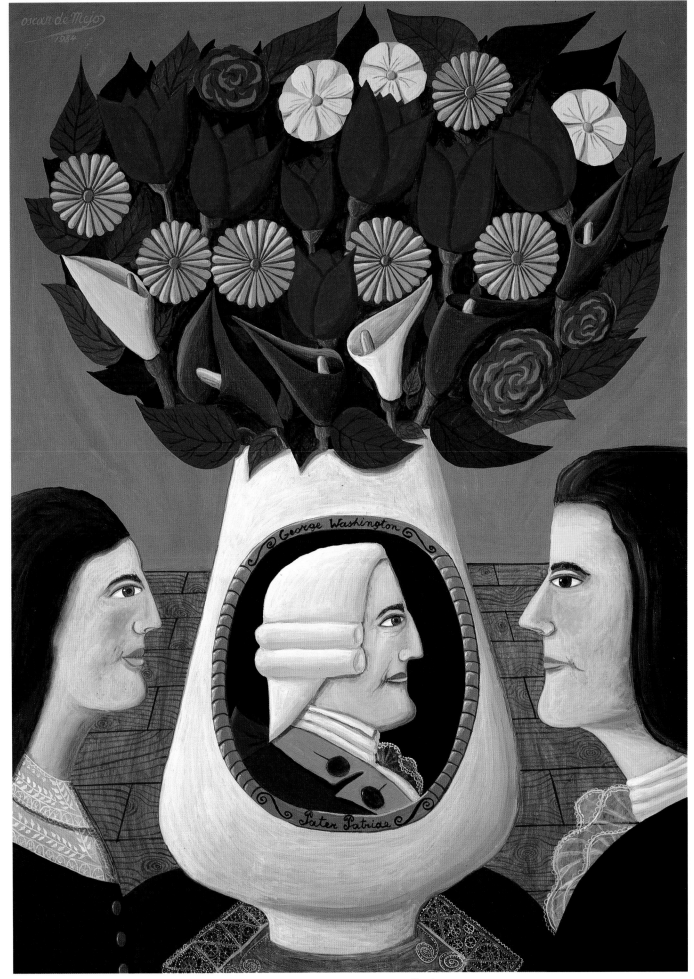

MEETING WITH GEORGE *1985. Canvas, 36 x 24". (See commentary page 136.)*

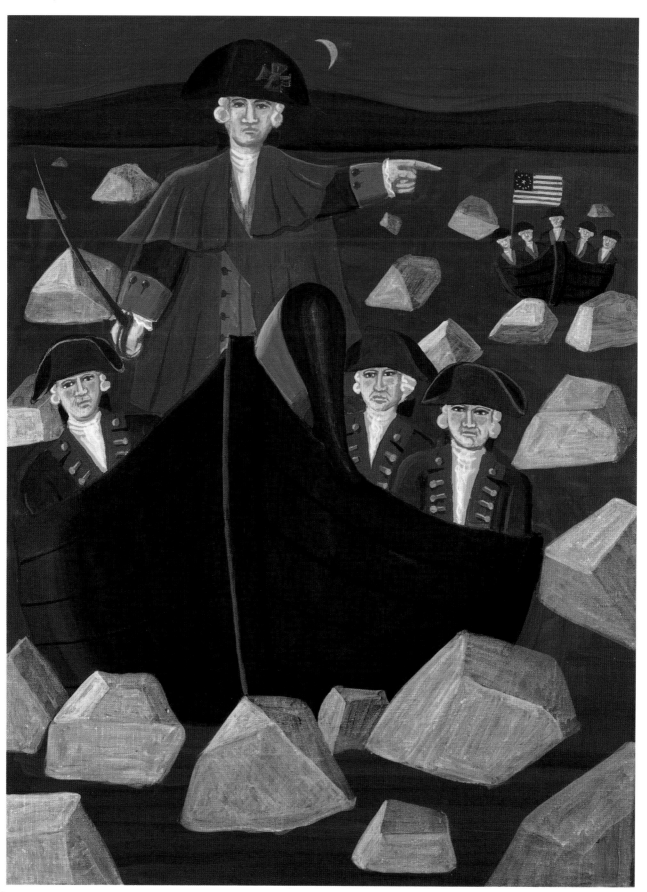

CROSSING THE DELAWARE *1986. Canvas, 24 x 18″.*

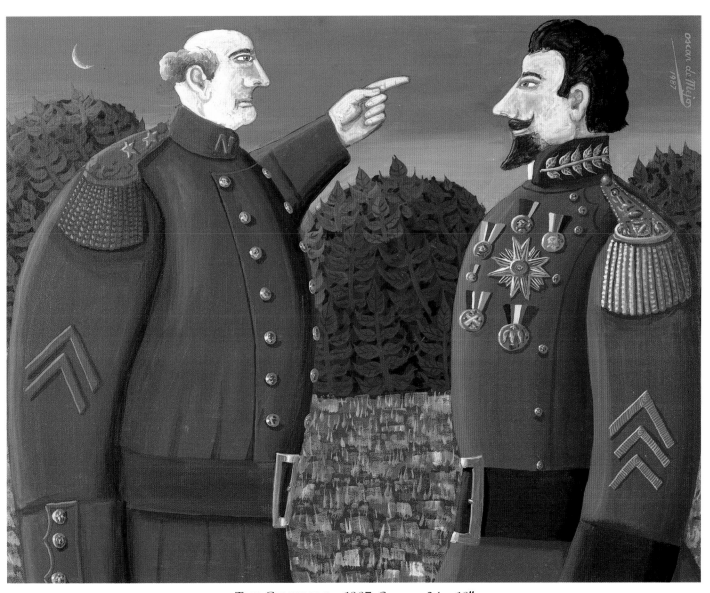

THE GENERALS *1987. Canvas, 24 x 18".*

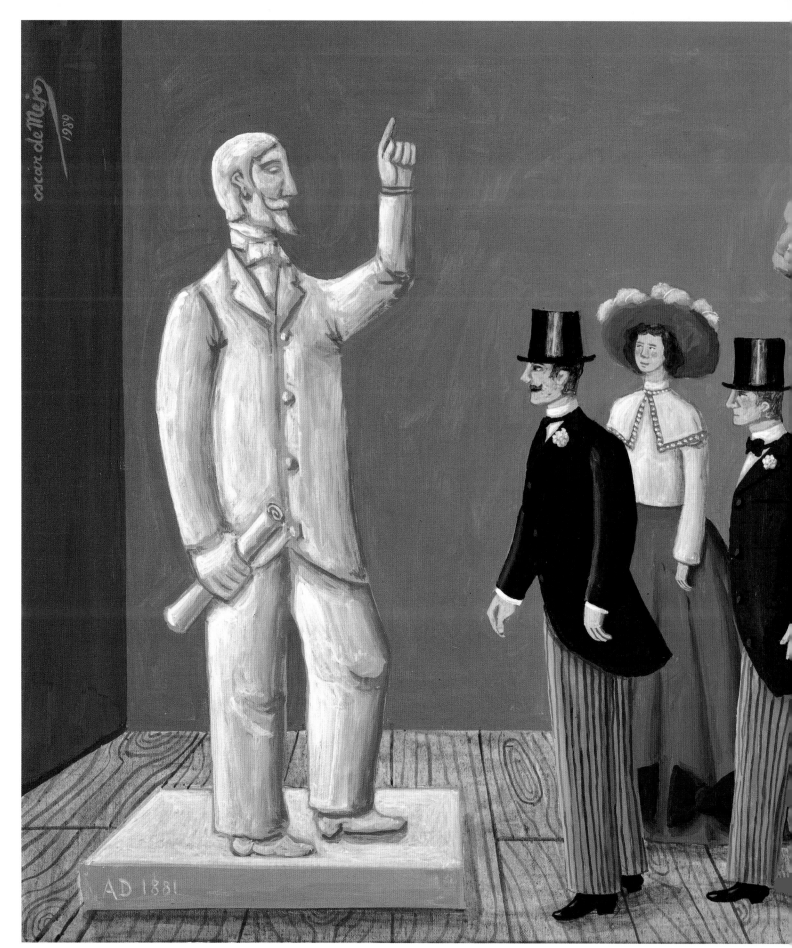

THE UNCLE IN THE MUSEUM *1989. Canvas, 20 x 24". (See commentary page 137.)*

General wanted to prepare for him a surprise art show at the consulate. I was naturally flattered by the request and agreed to supply the pictures.

And so in a little salon at the Italian Consulate twelve of my paintings were hung depicting the highlights of Garibaldi's life. There I entertained three important guests – the Premier of Italy, the Italian Consul General, and the Italian Foreign Minister Giulio Andreotti. Premier Craxi knew much more about Garibaldi than I did. He even told me the name of a friar I had painted in the picture of the Battle of Calatafimi. Andreotti commented that my paintings reminded him of ex-votos. I had heard this intelligent remark a number of times in my career. In fact, I have always associated my style of painting and that of other modern folk artists with the style of those who painted the votive paintings – we are all part of the same family of artists. Before leaving, Premier Craxi gave me a beautiful collection of coins which had been issued by the Italian Government for the Garibaldi Centennial in 1982.

On one of his visits to Manhattan, Vittorio Emanuele di Savoia, the son of the last king of Italy, Umberto II, asked me if I would introduce his eighteen-year-old son, Emanuele Filiberto to New York's art world. Since I knew the young man and admired his knowledge of art, I accepted with enthusiasm. It was a week of pleasant experiences. My young friend and I visited the building at 41 East Fifty-seventh Street and all its galleries. There I was able to introduce him to Marisa Del Re. Then we went to Christie's auction house, followed by a tour of the Metropolitan Museum of Art, where Everett Fahy, director of the European Paintings Department, offered to be our personal guide. Later we went to Soho to meet my friend Leo Castelli at his gallery there, and, of course, to tour Nahan Galleries, which still handles my work. Emanuele Filiberto was at the time posing in Switzerland for a portrait by one of the major artists of the century – Balthus. Incidentally, Balthus is one of my favorite painters.

After the show at the Bayly Museum, *American Heritage* magazine published an article about my work reproducing in color the ten paintings on the history of Virginia which I had done for John Kluge. Another article by Barbara Emde depicting me as a patriotic storyteller had also appeared recently in Germany in *Architectural Digest.* More requests of pictures for reproduction came to me from other magazines such as *Art Today, Sciences, Harper's, International Economy, Town and Country,* and so forth.

All in all my life as an artist was proceeding satisfactorily, and with welcome recognition. In particular a children's book by Rabbi Marc Gellman called *Does God Have a Big Toe?,* for which I painted eight biblical scenes, won an award from the *New York Times* as one of the ten best illustrated books of the year.

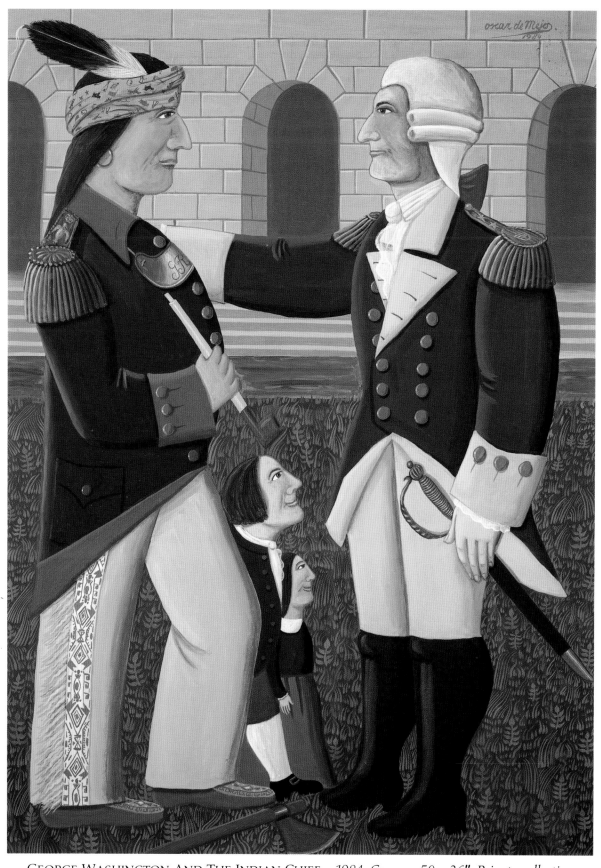

GEORGE WASHINGTON AND THE INDIAN CHIEF *1984. Canvas, 50 x 36". Private collection.*

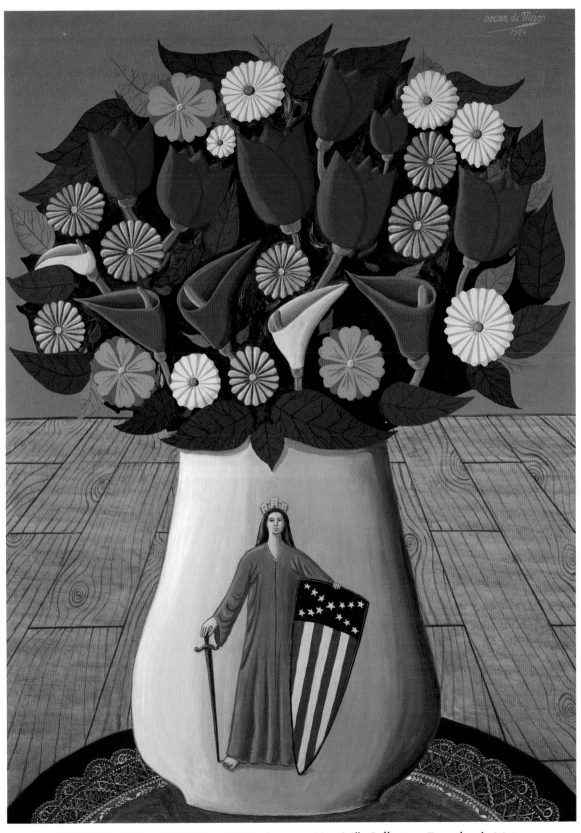

FLOWERS AND AMERICA 1984. Canvas, 50 x 36". Collection Dorothy de Mejo.

WALL STREET SECRET MEETING 1989. Canvas, 36 x 50". (See commentary page 137.)

I had illustrated and indeed written children's books before. This facet of my career began when Eddy, my wife's nephew, visited us. He was a ten-year-old child with a great feeling for art, very intelligent, very alert. To entertain him I showed him a book of my drawings, and when he saw the odd-looking characters I created he laughed and was greatly amused, especially by a gentleman looking very much like a bird. The fact that I was able to entertain a child with my drawings and stories gave me an idea: Why not write a book for children? That's how my first children's book, *The Tiny Visitor,* came to be.

My formula was to have a few lines of text for each page and a pen-and-ink drawing which complemented the text. I tested it by showing a complete manuscript to an Italian friend visiting me in New York, none other than Gillo Dorfles. He loved the book, and I promptly passed it on to my literary agent – Gloria Safier. The book was published to wonderful reviews and was selected by the *New York Times* as one of the ten best illustrated children's books of 1982. Another book followed, *There's a Hand in the Sky,* and later on a third, *The Forty-niner.* All three books dealt with the adventures of two rich Victorian sisters from Pomona, California. One critic from *People* magazine wrote, "Magritte would have loved these stories."

Recently I have written *Journey to Bocboc: The Kidnapping of a Rock Star,* and I am doing a sequel to the stories of the two Victorian sisters from Pomona. After the success of Rabbi Gellman's book, I signed a contract with Philomel Books to publish a number of stories, one of them being *La Bella Magellona,* about a girl in love with a man too small for her to marry.

Of recent events which had an influence on my life as an artist, I must recount a wonderful trip to Venice in 1990, my zillionth trip to that city, which again brought me in contact with the world of art at its best. I visited several museums and in particular I went to the Accademia to see the marvellous renditions of fifteenth-century Venetian life by Gentile Bellini.

The month I spent in Venice was also a great gastronomical experience. And it might as well have been so because upon my return to New York I fell into a very unhappy period of ill health which kept me for several months separated from any decent nourishment. Health came very slowly back with one peculiar discovery – my painting technique had improved considerably. During the months I spent in the hospital my subconscious mind had continued to work for me solving problems pertaining to my art which I was never able to master previously.

I feel quite comfortable with my brushes now, perhaps as never before, and I also have acquired a solid conviction that what I am doing is serving a purpose which, if not recognized yet, will be eventually. With these positive thoughts in mind I happily continue to paint.

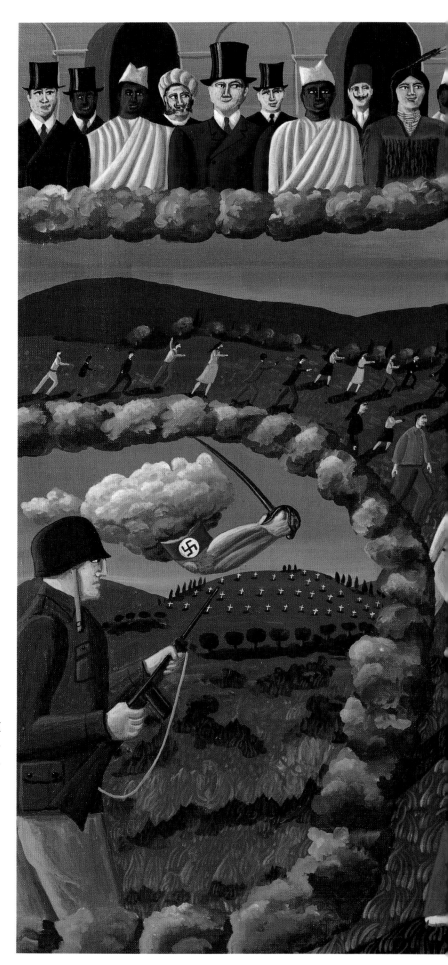

THE AMERICAN DREAM
1975. Canvas, 26 x 36".
Collection Bob Guccione and Kathy Keeton.

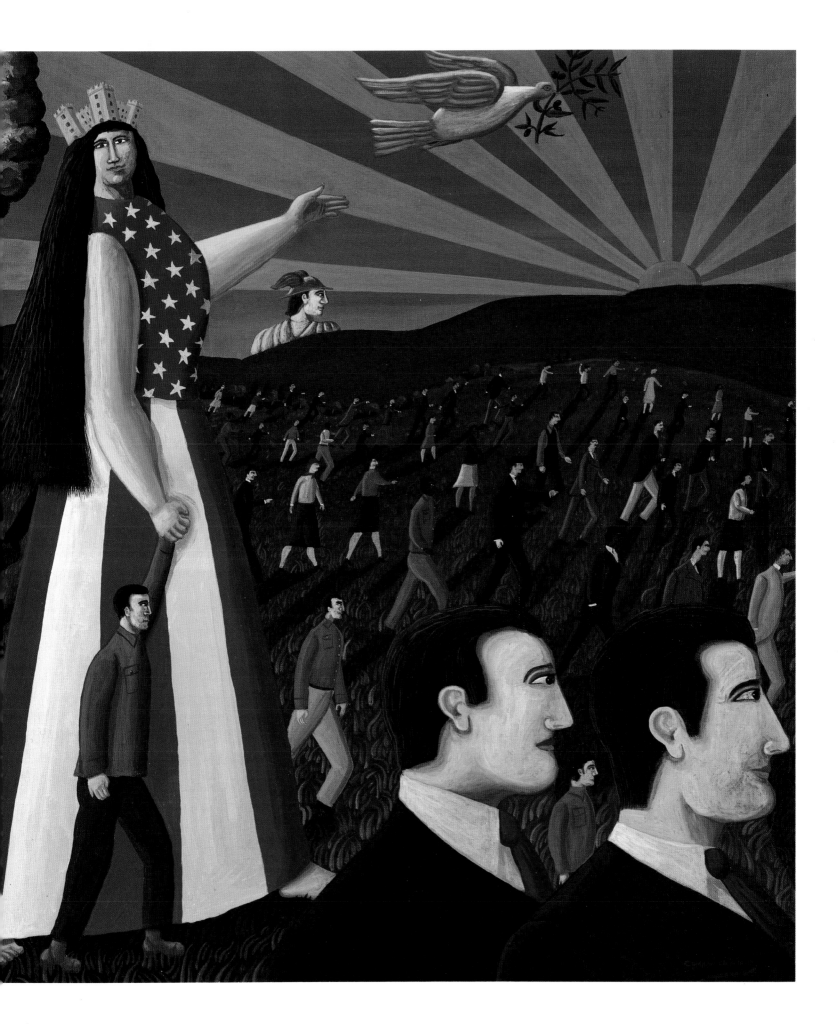

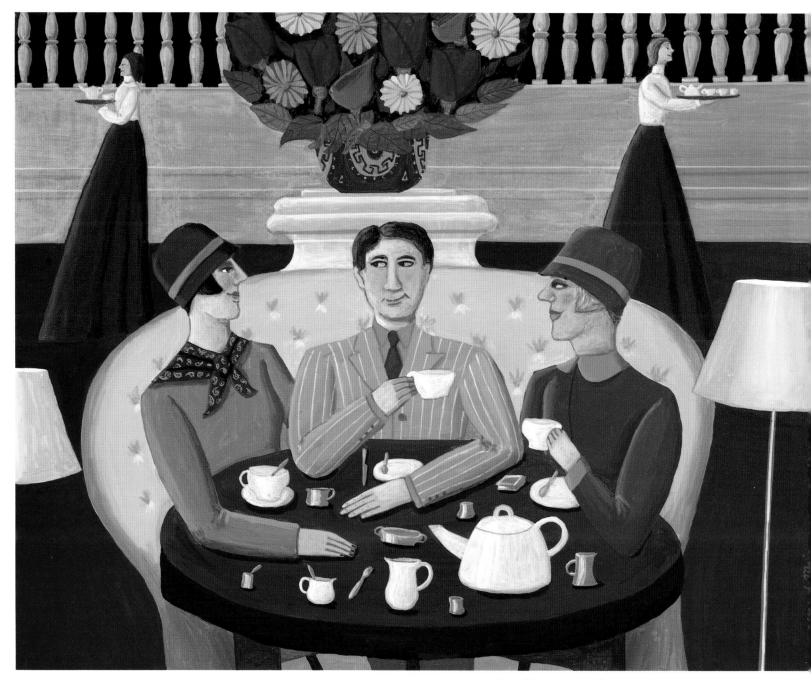

Tea At The Mayfair Regent *1988. Canvas, 22 x 28". Collection S. Nahan.*

WHILE HER FRIENDS DANCE *1990. Canvas, 12 x 15". From the book,* La Bella Magellona and the Little Cavalier.

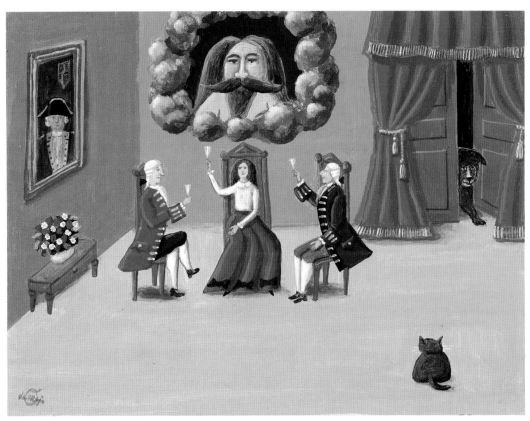

THE TOAST TO THE HERMIT
1990. Canvas, 12 x 15". From the book, La Bella Magellona and the Little Cavalier.

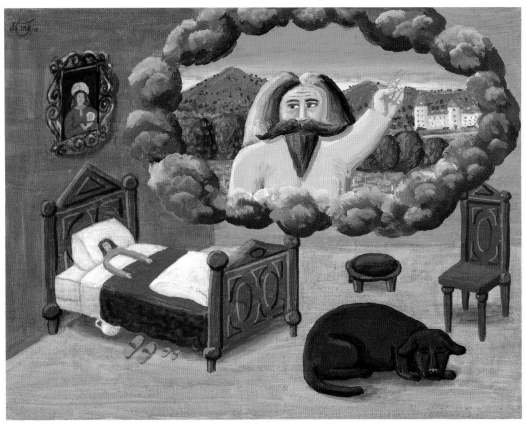

THE DREAM
1990. Canvas, 12 x 15". From the book, La Bella Magellona and the Little Cavalier.

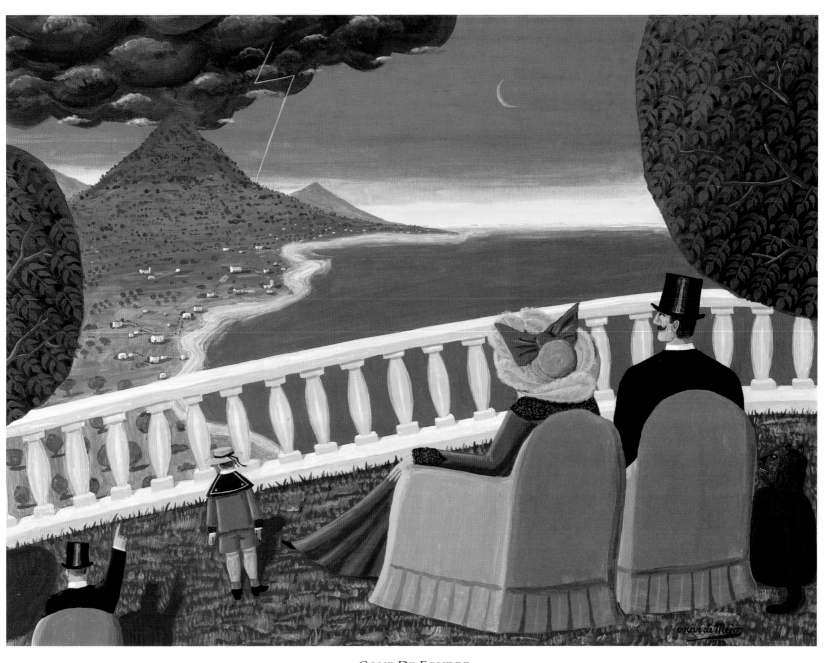

COUP DE FOUDRE
1989. Canvas, 30 x 40". Collection Christine Wheeler. (See commentary page 137.)

THE DREADNOUGHT
1986. Canvas, 36 x 50". Collection Christian Dubruel.

54

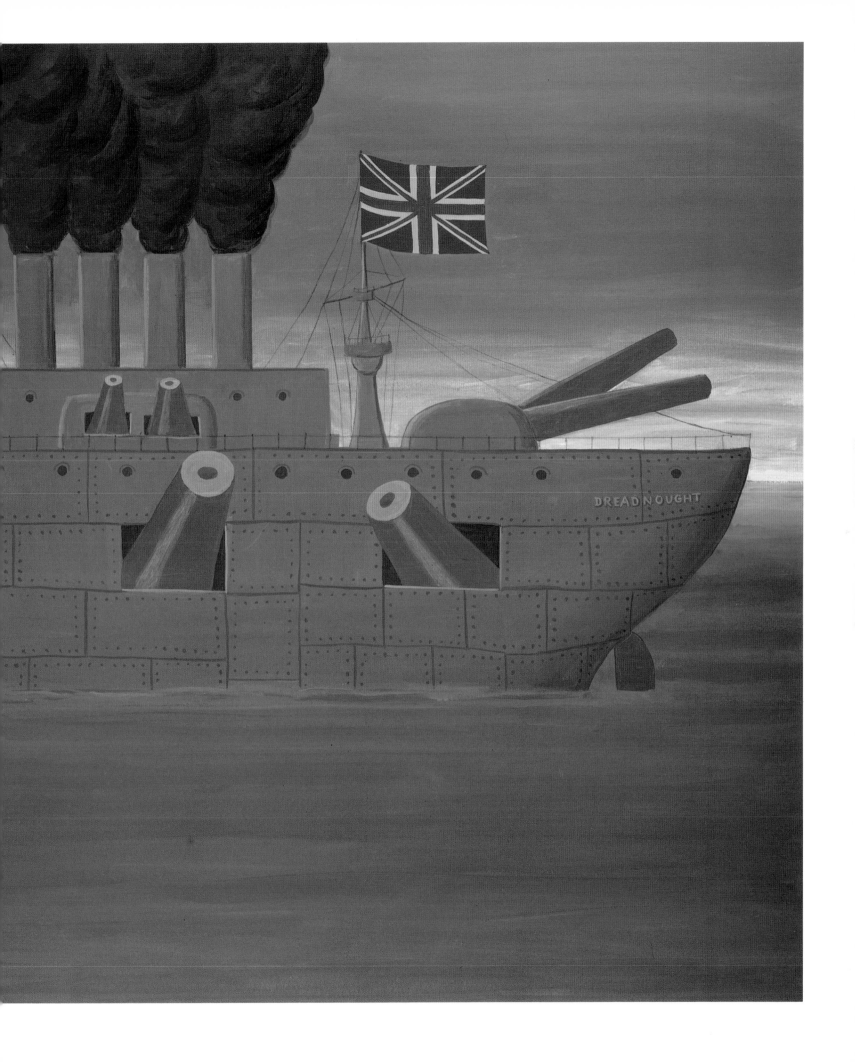

MIDRASH
1988. Canvas, 23 x 18". From the book, Does God Have a Big Toe?

THE RAINBOW OF BIRDS

ADAM AND EVE

NOAH'S ARK

CREATION

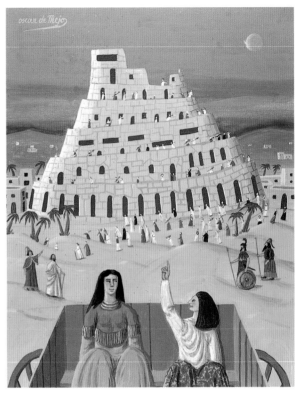

THE COAT OF MANY COLORS

TOWER OF BABEL

THE BURNING BUSH

ENOCH AND THE ANNOUNCING TOOL

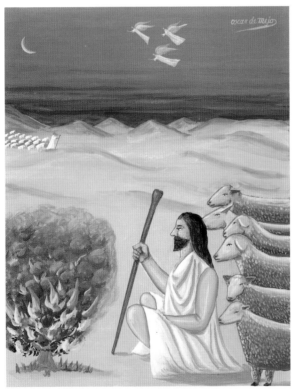

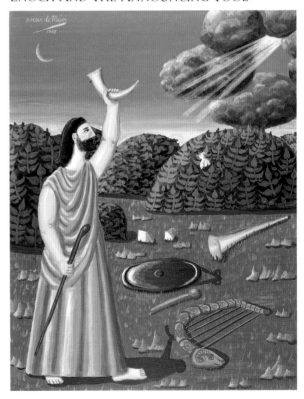

OSCAR DE MEJO:
THE NAIVE SURREALIST

Robert C. Morgan

For a man so concerned with the supernatural, Oscar de Mejo presents himself as rather ordinary. This is not to say that he is ordinary, because he is not; he is ordinary only to the extent that he lives in an ordinary world, a world of diurnal routines and habits, a world of occurrences and reoccurrences. De Mejo's interest in the supernatural is related to how he perceives reality. It is a means that allows him passage into another world. For de Mejo, the ordinary world is filled with things and events that are too often assumed and overlooked. Through his ability to perceive beyond what is normally taken for granted, the artist finds meaning, a sense of himself. Every object, every circumstance, becomes potent with significance. To explore the details of the world–whether it be the turn of an eye, the gesture of an arm, the lift of a leg–reveals something extraordinary. It is precisely this extraordinary vision that de Mejo encompasses in his art.

When historians discuss the work of naive painters, there is always the lingering question: What makes a painter naive? Is it a particular style, a measured way of flattening forms in pictorial space, a type of bright color, a certain childlikeness? Or is it some form or combination of these characteristics? Is there a kind of simplicity or reduction? What about exaggeration? Does the naive painter tend to embellish or distort in order to project his vision beyond the mundane world of appearances? Does he see reality in different terms, and consequently, does this difference allow a certain closeness to the spirit of things, a kind of obsessiveness?

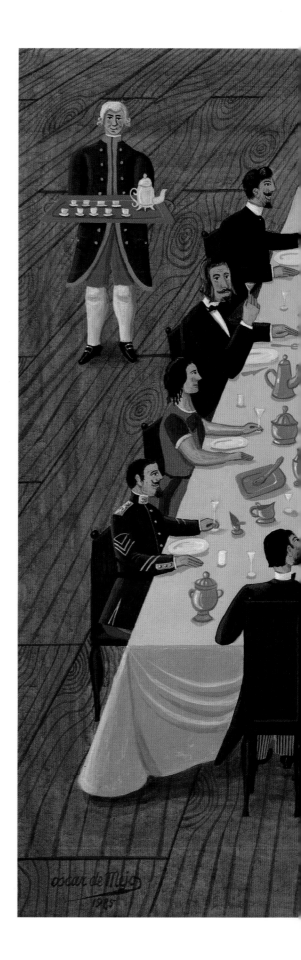

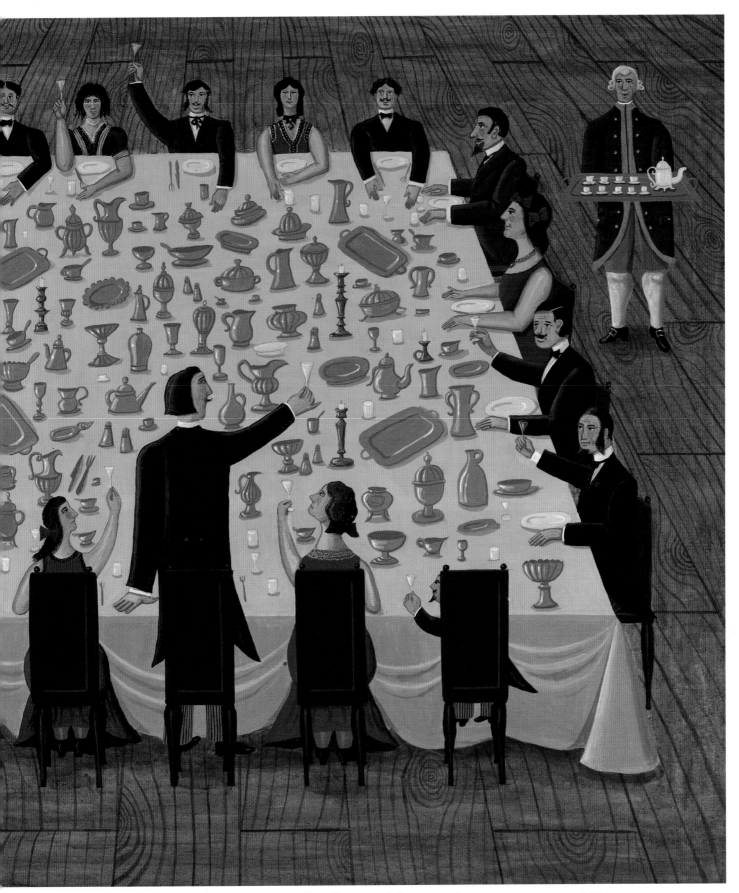

THE TOAST *1985. Canvas, 38 x 48". Collection of the artist. (See commentary page 137.)*

The fact is that some painters fit these characteristics and some do not. Clearly André Breton was interested in the paintings of Henri Rousseau not because they exemplified reality as truth in the normative sense of a deeply held aesthetic position but because they formed the basis of another world, a supernatural reality, a world of dreams. It was this dreamworld reality that attracted Breton, the leader of the Surrealist movement, to identify Rousseau's paintings as purely visionary and untainted by the academic institutions of art, the schools, and the museums. What Breton saw in Rousseau was a kind of heroism presented in childlike terms. Rousseau was a hero in the sense that he was able to maintain contact with the unconscious while simultaneously living in the conscious world. It was this edge of potential madness that interested Breton, the possibility of maintaining an eccentric edge in consort with the world of dreams.

One can see this same quality in the paintings of Bosch and Breughel. However in Rousseau there is a more lucid degree of painterly sophistication. It is this quality that would seduce the members of the organized Surrealist group in 1925. The naive or raw attempts to disengage conscious memory from the movements of the hand often became subservient to the aestheticized fetish. Yet when one considers the hybrid relationship between the strictly naive artist, such as the Haitians that de Mejo discovered in New York in 1949, and the more sophisticated Surrealists, including Max Ernst, Dali, Tanguy, and Magritte, it becomes apparent that more than a single criterion is at stake. The presumed naiveté of artists like Rousseau or Sassetta reveals certain visual characteristics that are quite different from those of the classically trained Surrealists. On the other hand, one must also distinguish between the various approaches that were extant within the movement itself. For example, the automatism of Miró and later Masson

ROWING CONTEST, 1776
1975. Canvas, 22 x 28". Collection S. Nahan.

60

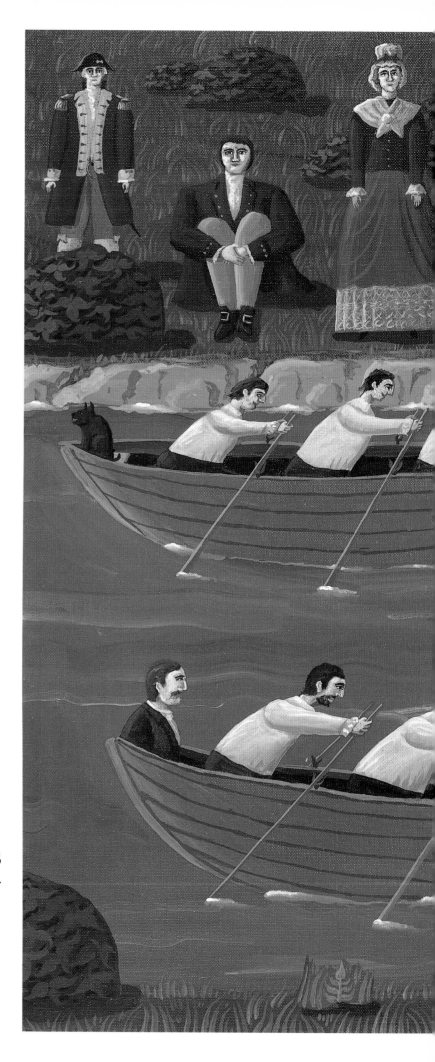

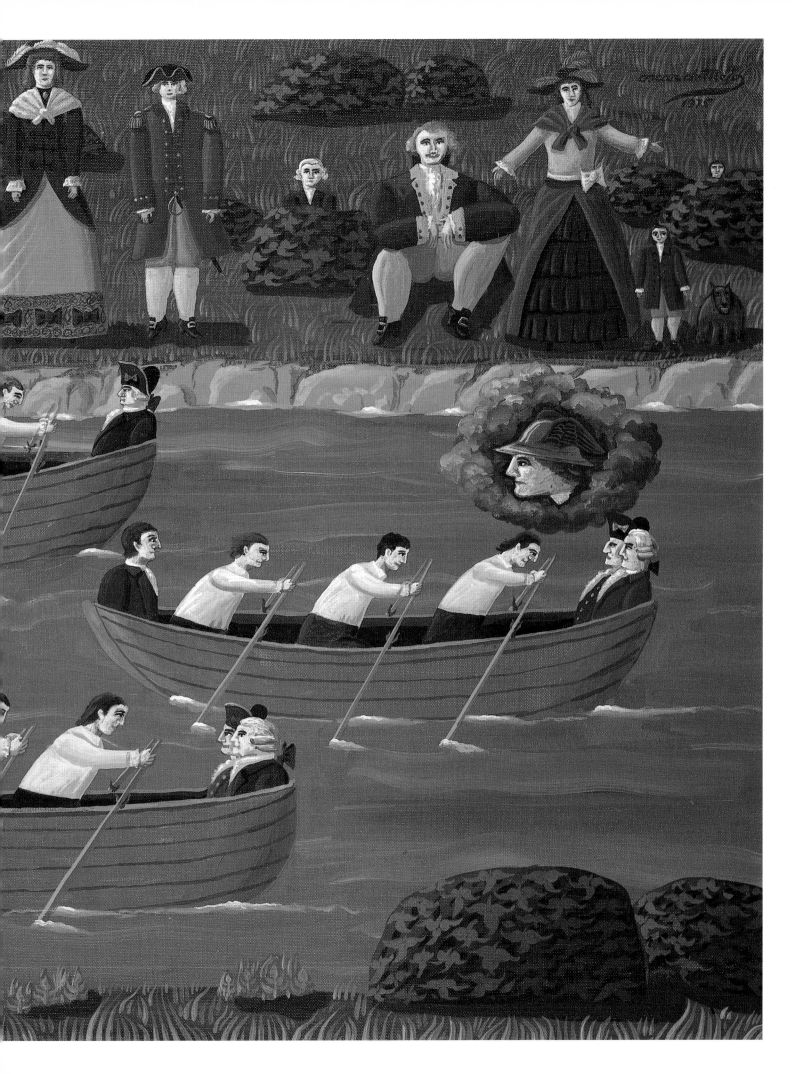

is different from the narrative interpretations of Dali, the unconscious symbolism of Tanguy, and the semiotic discourse of Magritte.

One may presume a quality of innocence in naive paintings that is less obvious in the work of the sophisticated artist from the academy. Although Surrealists often used techniques related to neoclassical painting as a basis for the erotic distortion of their images, naive painters were less concerned with this tradition and more given to the direct impulse that could communicate without any need for intellectual baggage. It is curious that Breton found this innocence very appealing in spite of the highly indulgent language of his novels, poetry, and manifestos. Both he and Wilfredo Lam were deeply interested in the work of the Haitians, especially the paintings of Hector Hyppolite, who, for them, carried the expressive stature of Picasso. Whereas the criteria for identifying naive (or what is sometimes mistakenly referred to as "primitive") art may be categorized according to the flattening of forms, the direct use of color, and the accentuated stiffness and disproportionate look of the figure, the criteria for identifying Surrealist art comes from another direction altogether. This is to suggest that naive art is not automatically Surrealist in concept, and that Surrealist art cannot be presumed to be naive. There may be a shared interest between the two camps, even a sharing of criteria; but ultimately they each emerge from a different point of view. One might go so far as to argue that the aesthetic origins of these genres are as profound as the differences in social or political beliefs, but this would be too complex an issue about which to offer a generalization.

What is interesting, for the moment, is to consider how the art of Oscar de Mejo touches on each of these criteria; but in order for this to make sense one has to come to terms with his own point of originality. There is, indeed, a level of sophistication in de Mejo's oeuvre that exceeds a purely naive connotation. While the appearance of the signifiers in his work is naive, it is plausible to argue that what is being signified is conceptually within the frame of Surrealism. De Mejo's interest and belief in the supernatural and the viability of the extraordinary circumstances in life–focused on the intimacy of understanding events in his own life–may lead the critical viewer to a wider comprehension of what the statement of his work contains. Just as the Surrealists were inculcated with the notion of mysteries in life and the paradoxical ironies of the

most banal situations, so too does de Mejo inject similar mysteries and banalities into his paintings. The fact that the paintings look more naive than Surrealist is perhaps as much a semantic distinction as an aesthetic one. Given the relatively graphic appearance of de Mejo's art–both in his paintings and numerous book illustrations–the deep structure of his content tends to be either ignored or overlooked. The structural permutations in his works are informed by various art-historical references and other sources in the popular arts. The play of signifiers in his work is rarely overt, but resides quietly on the surface. The innocence of his work has an immediate disarming effect, as if to somehow play down the structural and formal elements.

In this sense, one may consider de Mejo as having a kinship with Paul Klee. Though never associated with the Surrealists, Klee's fundamental formal expressionism offered a similar decoy. A Klee painting or gouache from the twenties in the Bauhaus period always made the formal apparatus apparent. The issue of subject matter, for Klee, seemed almost an afterthought relative to his emphasis on the pictorial structure. This becomes evident in his theoretical dissertation *A Pedagogical Sketchbook*, published while he was teaching in Weimar. As Klee's work progressed into the thirties, it became increasingly obvious that he was getting closer to his vision of spontaneity–essentially, what he always wished for–a vision with the complete directness of a child's drawing. As Klee desired this simplicity in his art, his use of the formal apparatus became, at times, less clear and less obvious.

A commonality between Klee and de Mejo is their relationship to music. Klee was an accomplished classical violinist; de Mejo sought a career in his younger years as a jazz pianist and a popular song-writer. In either case, there was a relinquishment of one form of art for another. One might also consider the fact that Klee's formalism never really left his art no matter how intuitive it became. One could say the same of de Mejo. No matter how disarming the "primitive" childlike vision might appear, there is another level of content and meaning that lingers on the surface, what semioticians refer to as the deep structure.

Still another element of comparison between the two artists is the sense of the absurd and the presence of humor as an antidote to the seriousness of formal discipline. There is a certain lightness

in both artists' work, a certain relief, and concomitantly a clear sense of resolution in the completion of each picture even when there is a mystery or a contradiction in terms of the narrative. Yet there are some important distinctions to be made between the artists. While Klee was completely absorbed in the abstract elements of his pictures, de Mejo's attitude is quite different. Klee used a more expansive vocabulary in the interpretation of subject matter and was less concentrated on a particular style. Whereas Klee plays close attention to surface variation as a type of formal delineation, de Mejo's pictures are much more crude and bold in their placement of shape and color. Klee never looks like a naive artist in spite of his childlike aspirations. De Mejo always looks like a naive artist to the point of almost disguising the dramatic subtleties that inspire the work. De Mejo wants to tell a story, to describe an occasion, and to convince the viewer that something is happening in the story that is completely unpredictable, even absurd.

There is a sentimental aspect to de Mejo's paintings that is a contributing factor to the work's naiveté. Sentiment in itself is not a criticism. It would be difficult to find a work of naive painting where sentimentality was not being expressed. One also finds a pervasive symmetry and a discrete arrangement of objects often represented in an ensemble on a field. This can take many forms. For example, take the painting by de Mejo from 1985 called *The Toast*. It is an early American scene. The rectangular table has a symmetrical trapezoidal placement in the center of the picture. Two matching wigged waiters stand at either side. The number of cups is precisely the same on each tray. The people at this extraordinary banquet are in a gay, festive mood. A standing male figure in the foreground, positioned at the exact center of the lower portion of the pictorial space, raises his glass in a toast. On the table, one can view the array of silver and pewter accessories. Every object has been evenly spaced. Nothing is behind or in front of anything else.

This formal device as been used often in de Mejo's paintings. Two other works from 1989, *The Happy Skaters* and *The Bird Lover*, repeat this distribution of evenly spaced elements within a contained field. In *The Happy Skaters* the pictorial field is an ice pond on which the tiny skaters are represented as flattened forms, thereby emphasizing the geometric configuration as an overall composition, a nexus

of molecular activity where space emits energy. *The Bird Lover* pays tribute to Magritte with the profile and bust of a top-hatted man caught within the dense dark leaves of a flourishing tree. The man in his formal attire is poised at the uppermost level among the branches and surrounded by the cropped heads of various birds, ranging from a canary to an owl to a toucan. The thick trunk of the tree forms the support for this ensemble which, in turn, is surrounded by the shadow from the leaves above. Again, it is the distribution of evenly spaced elements within the patterned representation of leaves that carries the weight of the composition. In addition to Magritte, one might also think of Max Ernst, whose interest in botany and biology informed many of his paintings. With de Mejo's *The Bird Lover*, there is another popular Surrealist theme, employed regularly by Ernst and Juan Miró; namely, the theme of bird-people or people being transformed into birds or birdlike creatures. The fantastic array of birds in de Mejo's painting echoes the sight of the dandy caught among the branches. Everything is flattened and absurdly cropped as if to suggest a morphology between the dandy and the birds, as if to represent a taxonomy where the dandy is simply another species within the pictorial field of these remarkable creatures. It all becomes a visual quandary.

As a Northern Italian who came to this country in the forties, de Mejo's sensibility could not escape the artistic influences of his homeland. Sassetta and Giotto, both early Renaissance masters, one "primitive," the other trained as an artist, represented the two poles of de Mejo's visual thinking. For anyone who has gone to Padua and seen the Arena Chapel in which the great Giotto frescoes are painted, the clarity of expressiveness in this narrative sequence is one of the marked features of the artist's style. Because Giotto was the major figure at the outset of the Renaissance when new ideas about humanism and classical rendering were beginning to find manifestation, there is a certain intensity in this storyboard format that encapsulates the spirit of these new ideas, specifically in their application to the Passion of Christ. The disproportionate relationship of the figures to the architectural renderings is particularly apparent. But most important is how well the painter Giotto was able to capture the agony and the strife, the joy and the humor, the immanence and the transcendence, endemic to this preeminent religious theme. One might also add the component of the absurd; for example, the humor of the betrayal in

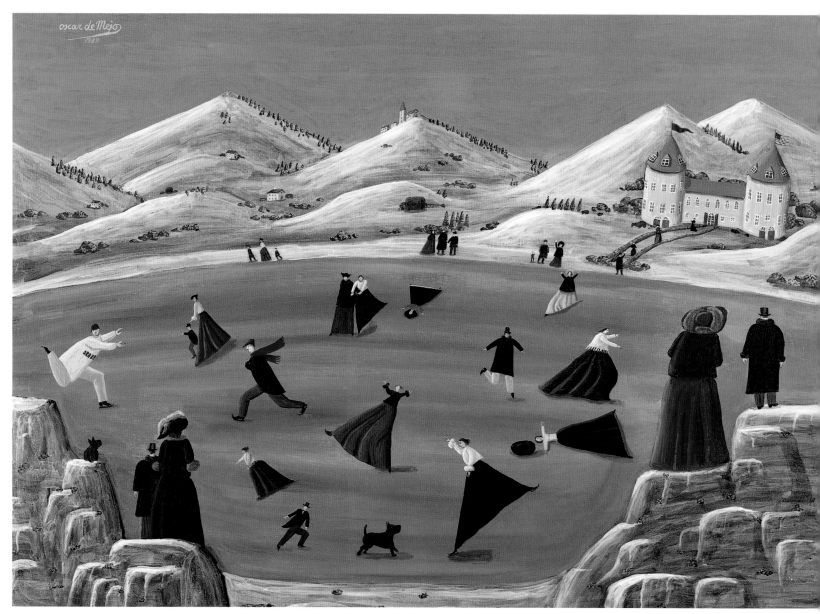

THE HAPPY SKATERS *1989. Canvas, 36 x 50". (See commentary page 137.)*

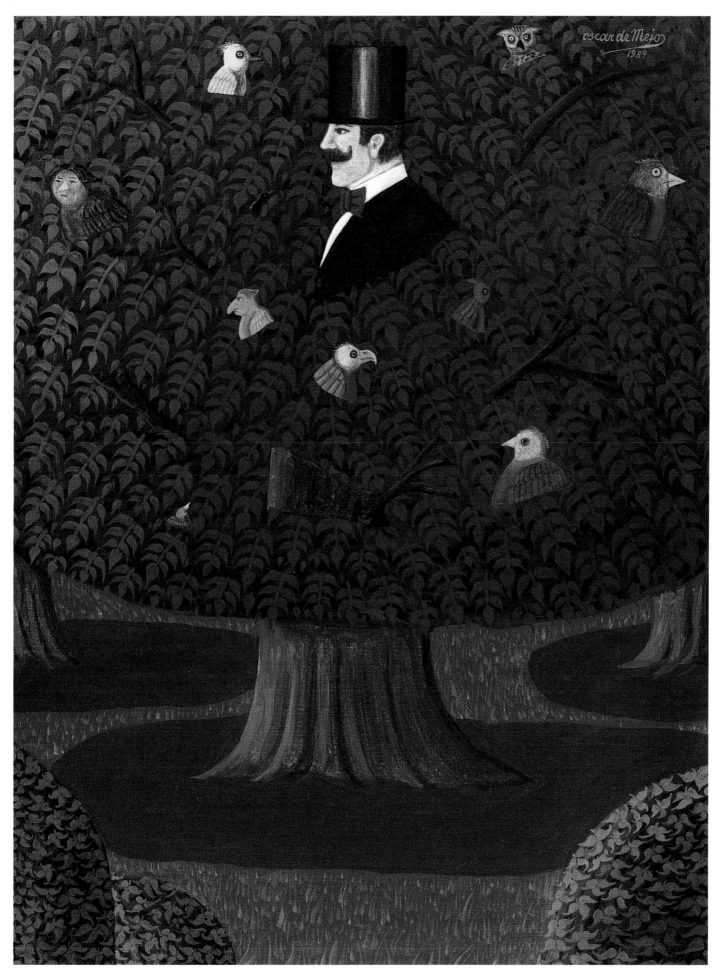

THE BIRD LOVER *1989. Canvas, 40 x 30". Collection S. Nahan. (See commentary page 137.)*

which the Apostle Judas gives away his Master by kissing him in the garden filled with soldiers. One does not normally associate humor with this tale, but if one examines the tragicomic circumstances of the event, one may discover the absurd action as the only resolution. Giotto has captured it so well.

In de Mejo's book, *My America*, published by Harry N. Abrams, Inc., in 1982, there is a wonderful painting called *Washington's Farewell (1783)* that depicts the theme from the American Revolution when the General bids farewell to his officers at the Fraunces Tavern in New York. The central portion of the painting has the General embracing one of the officers while the flanking members of the party look on. The skepticism and doubt in the eyes of the spectators, not to mention Washington himself, convey political deceit and hesitation. The scene, as it is painted by de Mejo, reflects a mood that is not unlike the one posed by Giotto. Within the

pageantry of the moment, there is an acknowledgment of human frailty.

This all-too-human quality is reiterated in de Mejo's *The Game of Poker* (1988), a curiously convoluted concept involving the three royalty–King, Queen, and Jack–seated together at a card table in a symmetrical arrangement. The shifting eyes of the King, replicating the image on the cards, is directed toward the Jack who is seated to his right. The Jack's eyes are directed across the table to the Queen, who sits on the King's left side. The complicity of this action is humorous, especially when one observes the framed image of a ten of hearts behind the King's left shoulder. There is the same distrust and skepticism in *The Game of Poker* that one might acknowledge in *Washington's Farewell (1783)*. Linguistically, however, there is the added element of the tautological folding-in, as it were, between the players who reiterate what is in the cards. The

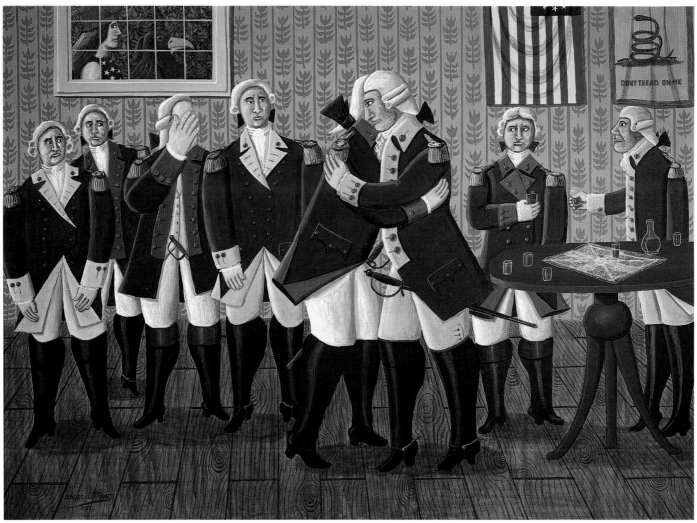

WASHINGTON'S FAREWELL *1982. Canvas, 36 x 50". Aberbach Fine Art.*

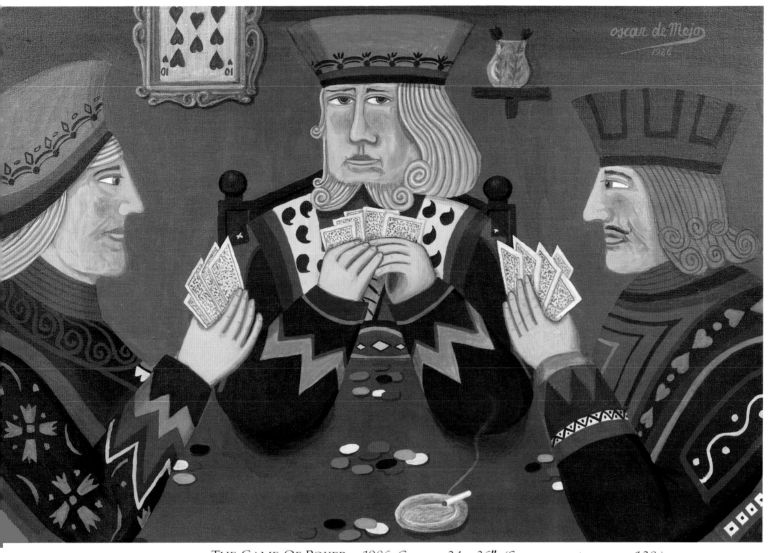

THE GAME OF POKER *1986. Canvas, 24 x 36". (See commentary page 138.)*

absurd ominous action is further reinforced by the presence of a small glass jar containing two darts on the shelf over the King's right shoulder, weapons perhaps intended to be used against his seated opponents. The realm of fiction is turned inside out in a kind of Magrittean palimpsest or play on images. This suggests again that the content of de Mejo's painting carries the sophistication of the Surrealists even though the style is clearly that of a naive artist.

It is interesting to note that de Mejo frequently uses three figures to create dramatic tension. The diversity of themes that he makes accessible within his clearly fixed style suggests that his vocabulary is flexible and that he can easily accommodate different strategies for narration within an economy of means. For example, *Cupid in the Park* (1984) and the hilarious *Ambush* (1985) each use three

characters but in completely different ways. In the former a man and woman, possibly from the twenties, sit on a park bench with a grown, somewhat ugly cupid in the foreground winking his eye at the observer of the spectacle behind him. *Ambush* makes use of the profile, as in *The Bird Watcher*, but concentrates specifically on three Indian heads peering from above a densely verdant setting. The similarity between the three heads is remarkable except for the decorative variations of the war paint and the fact that one of the heads is adorned by two feathers instead of one. This repetition of countenance is not unrelated to the naive style used by the British poet-painter William Blake. It is, perhaps, another generalized characteristic of naive painting. Also, the exuberant patterning of the discrete bunches of leaves offers a euphoric tour de force of inventive stylization in de Mejo's painting.

67

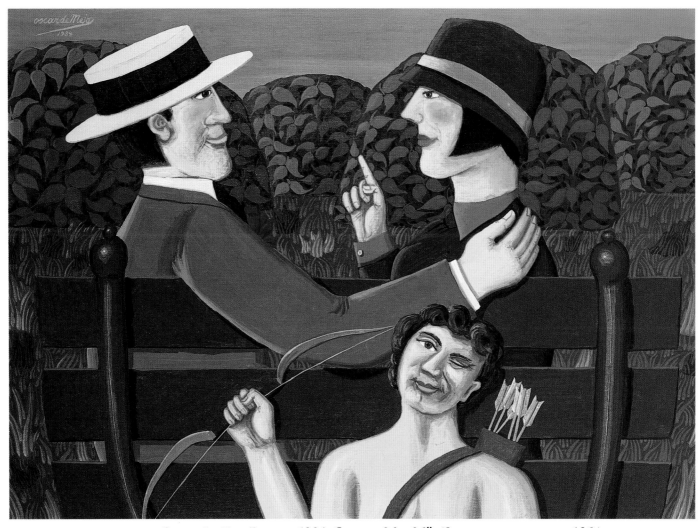

CUPID IN THE PARK *1984. Canvas,.26 x 36". (See commentary page 138.)*

At the other extreme from Giotto is the influence of the fourteenth-century Siennese painter Sassetta. Long recognized by Renaissance art historians as a "primitive" master, Sassetta's use of the flattened figure against a field and the pronounced brilliance of color suggests an immediate source for de Mejo's figurative interpretations. A third Renaissance artist should also be mentioned in this regard, and that is Paolo Uccello. It would be difficult to miss the influence of Uccello in such works as de Mejo's *The Four Horsemen of the Apocalypse* (1990). The great battle scenes of Uccello reveal an abundance of horses and spears with a fastidious attention given to the exact placement of each component.

This precision of spatial location is typical of the paintings of de Mejo as well. In *The Four Horsemen,* for example, the four equestrians are positioned in a frontal manner as if charging toward the viewer. The use of foreshortening is

apparent, but not obvious. For the most part the bodies of the horses are rendered with a flat use of color. A minimum of gradation has been used in this painting except for the cumulus clouds hovering angrily above a bright yellow sunset in the background. Even a picture as foreboding as this is redolent with de Mejo's characteristic sense of the absurd.

It would be implausible to confirm a Surrealist content in the work of de Mejo without alluding to two of the most often revealed aspects of the movement: 1) the juxtaposition of irrational elements within the picture, and 2) the suggestion of a dreamworld eros or release from the repressive circumstances of the ego. Of the Surrealist painters, the most lighthearted was Juan Miró. He was less concerned with narrative and more focused on the automatic expression or impulse than was Dali in the thirties and Magritte and Ernst throughout

68

their careers. Yet the painterly intuitiveness of Miró, especially his allegiance to automatism as a truly Catalan method for expressing meaning, is not shared by de Mejo. What de Mejo does share with Miró is his spirit of play.

Another emphasis should be made in relation to de Mejo's art, and this is of crucial importance. De Mejo was not a member of the Surrealist group, and his contact with members of the group was minimal. De Mejo is an original to the extent that he has persisted in his uniquely naive vision without attempting to follow in the tradition of the visual narrative techniques of Surrealism. Given his orientation toward a flat graphic style, de Mejo's peculiar hybrid of naive form and Surrealist content lends itself well to illustration. It is within the realm of illustration, particularly in his many marvelous

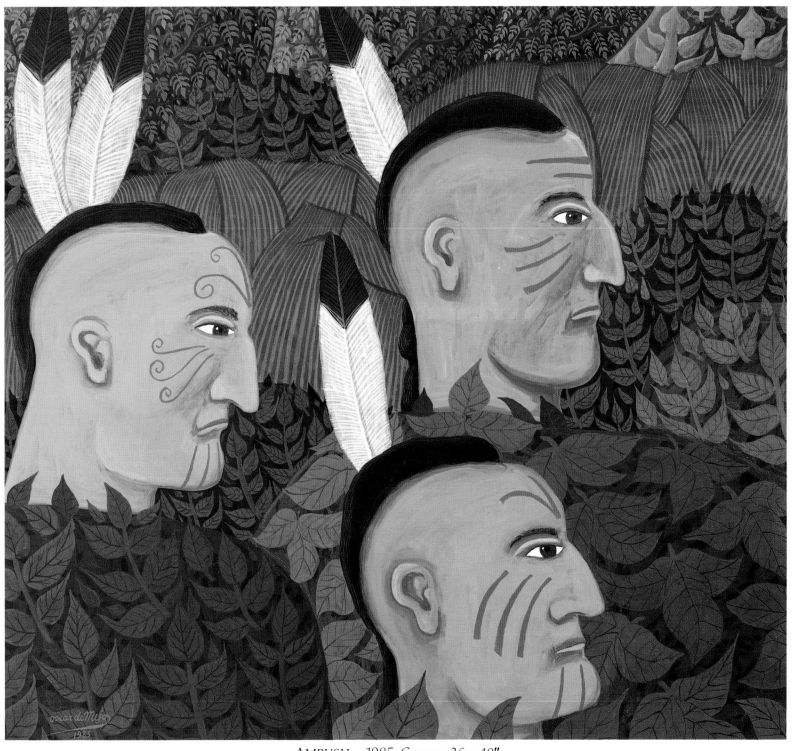

AMBUSH *1985. Canvas, 36 x 40".*

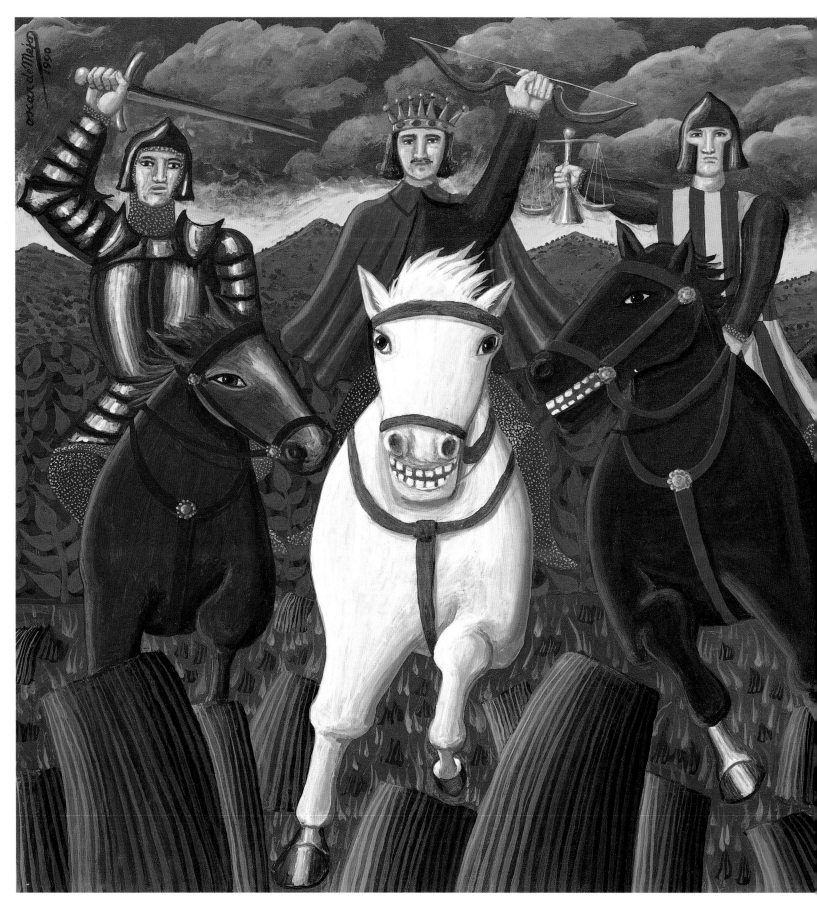

THE FOUR HORSEMEN OF THE APOCALYPSE *1990. Canvas, 36 x 40". Private Collection.*

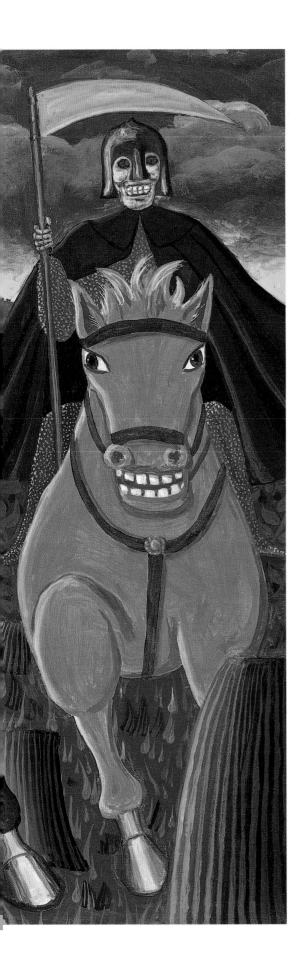

children's books but also including the commissioned series of works on the American Revolution and the Harlem Globetrotters, that Oscar de Mejo has made his major impact. It is no accident that he likes to give captions or little epigrams to his paintings. De Mejo is aware that he is telling a story. The manner in which he tells the story is one of complete visual involvement with his subject matter, and relies both on irrational juxtaposition and a strange sense of fantasy where the revelation of the ego is quietly unraveled through his various representations of character.

A further point should be made in regard to de Mejo's interest in early "anonymous" American painting, the kind of painting that was, for the most part, untrained and "primitive" in its representations, primarily of portraits and genre scenes. This, combined with his interest in Haitian paintings and votive tablets, provides a highly imaginative sourcebook of technical nuances that can be traced through de Mejo's career as a painter.

What comes across most strongly in de Mejo, both as an artist and as a person, is his extraordinary sense of wonder combined with an intensely gentle and resolved manner of being. After all, de Mejo is more humanist than narcissist. This should be mentioned in view of the fact that so much Surrealism is concentrated on the ego–a veritable celebration of the ego!–as the reservoir and guardian of creative energies. With de Mejo, the ego seems too overrated as a mechanism for the production of sensational works intended to project the inner meaning of the psyche as a cosmological sign. It is not the ego that comes across in de Mejo's work so much as a slow and deliberate process of executing an idea. He is an artist who is not afraid of play. Real play cannot occur without some sense of responsibility to the audience being addressed. It is this understanding of playfulness as a social reality that gives de Mejo's art an historical reality. What we see in de Mejo's art is not a foreboding sense of humanism as another negative utopian phenomenon, but a reaffirmation of the values that sustain a real possibility for intimate experience amid the chaos of a post-industrial world. Indeed, for a man so committed to his belief in the supernatural, Oscar de Mejo is amazingly down to earth. His power as an artist lies in his ability to show how the hidden glances and gestures that are often neglected on the surface of reality also provide us with the ability to see ourselves afresh and without the encumbrances of rational meaning at the forefront of behavior. Oscar de Mejo is a blessing without a disguise.

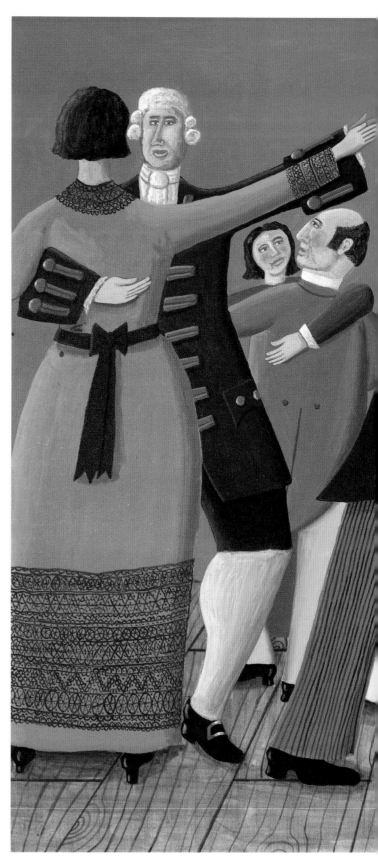

A SHOCKING ENCOUNTER
1990. Canvas, 11 x 15".
From the book, La Bella Magellona and the Little Cavalier.

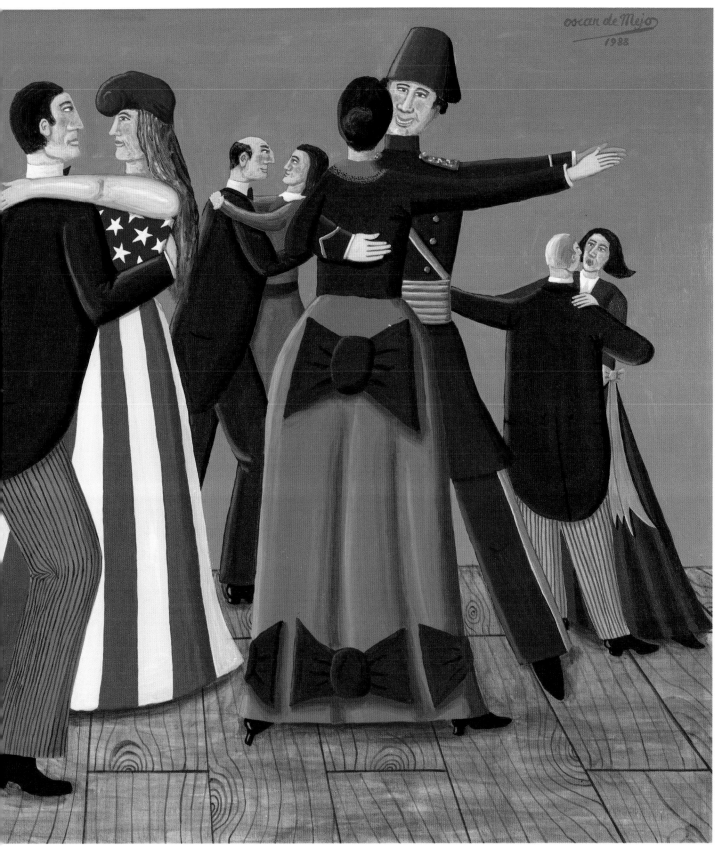

THE MASKED BALL *1988. Canvas, 36 x 50".*

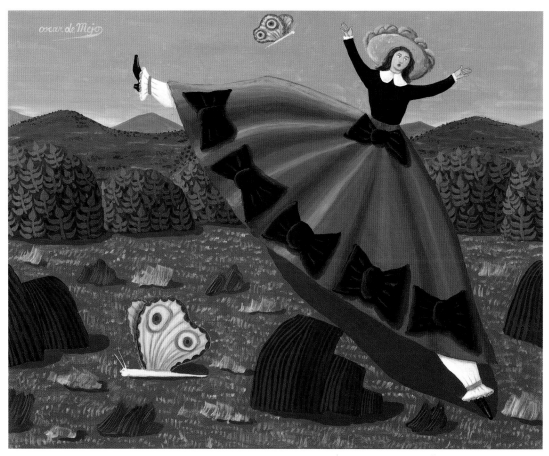

LADY AND THE BUTTERFLIES *1988. Canvas, 22 x 28".*

THE LITTLE CAVALIER *1990. Canvas, 11 x 15".*
From the book, La Bella Magellona and the Little Cavalier.

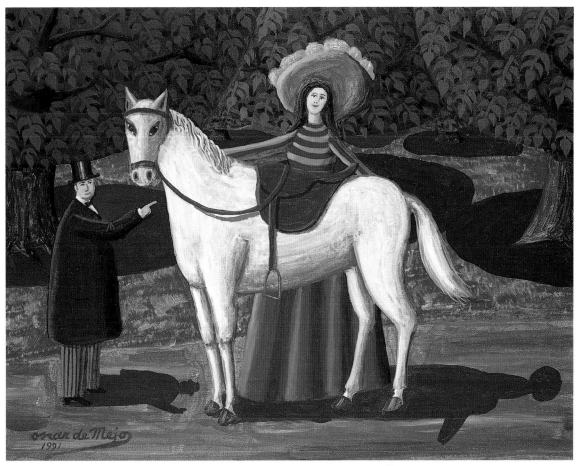

THE GIFT *1991. Canvas, 14 x 18".*

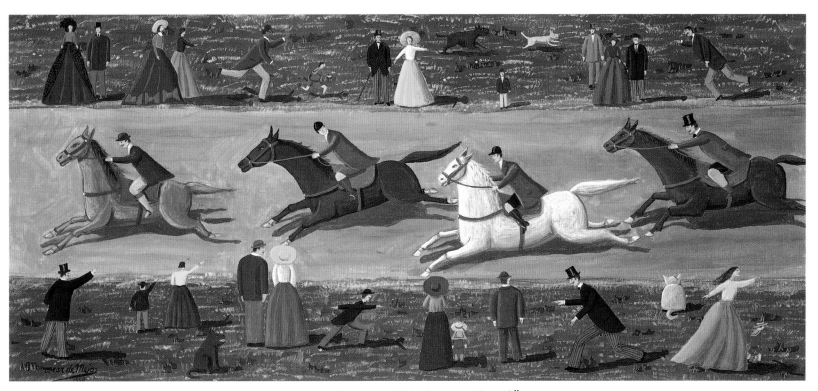

HORSE RACE *1990. Canvas, 18 x 40".*

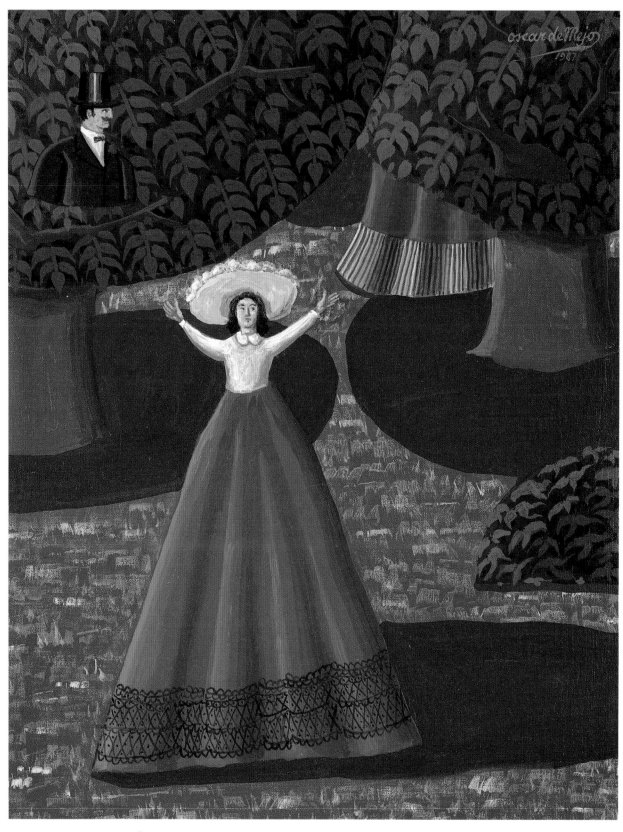

From the series, THE GAME OF HIDE-AND-SEEK *1987. Canvas, 18 x 14".*

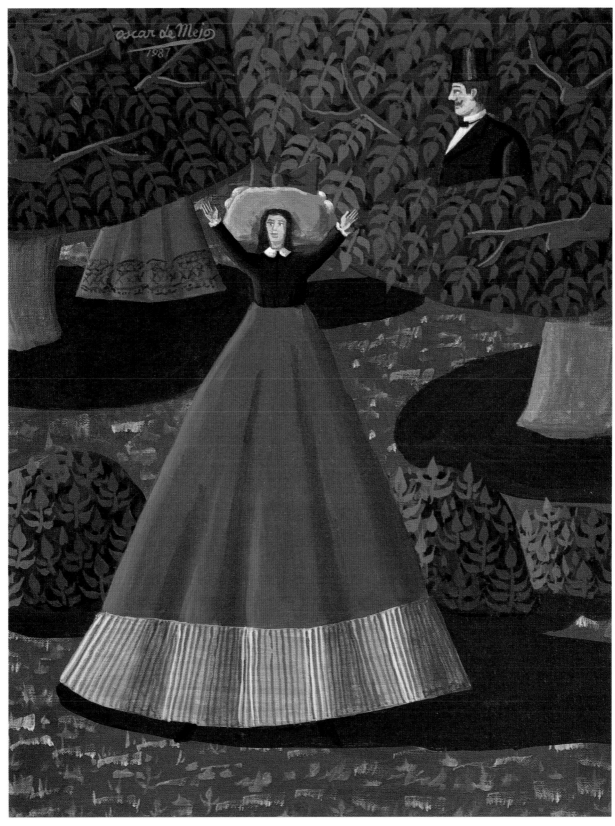

From the series, THE GAME OF HIDE-AND-SEEK *1987. Canvas, 24 x 18".*

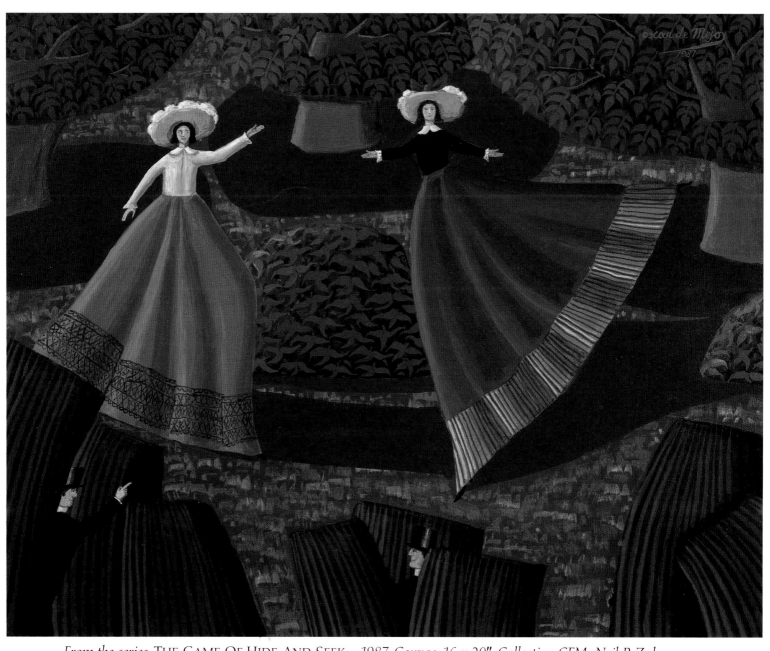

From the series, THE GAME OF HIDE-AND-SEEK *1987. Canvas, 16 x 20". Collection CFM–Neil P. Zukerman.*

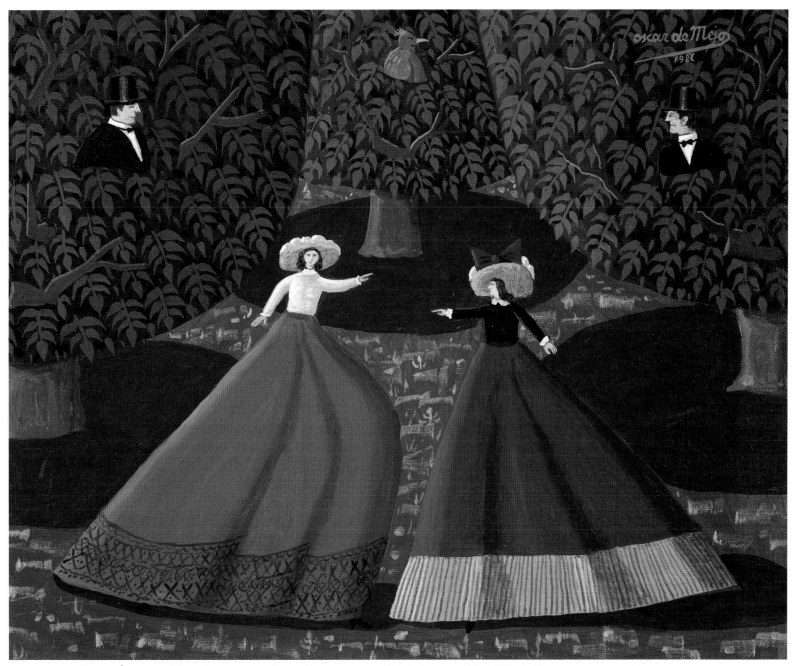

From the series, THE GAME OF HIDE-AND-SEEK *1987. Canvas, 16 x 20". Collection Nancy and Lou Green.*

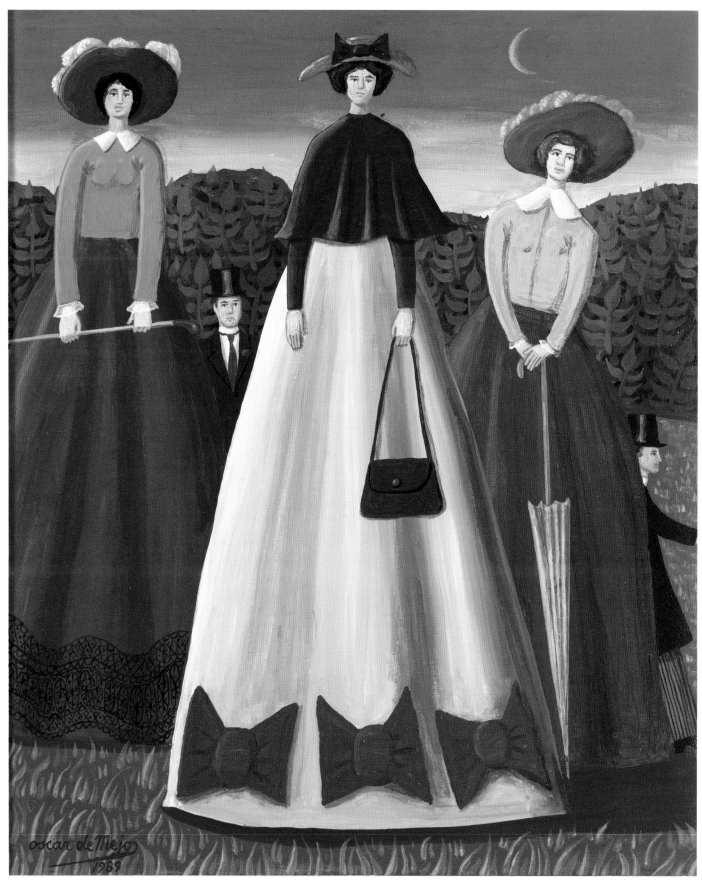

THE THREE TALL SISTERS 1989. Canvas, 24 x 20″. (See commentary page 138.)

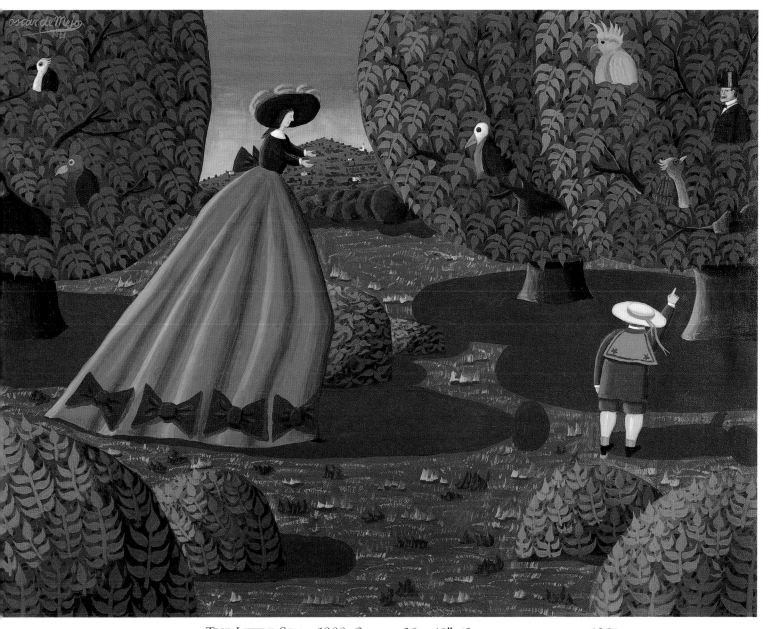

THE LITTLE SPY *1988. Canvas, 30 x 40". (See commentary page 138.)*

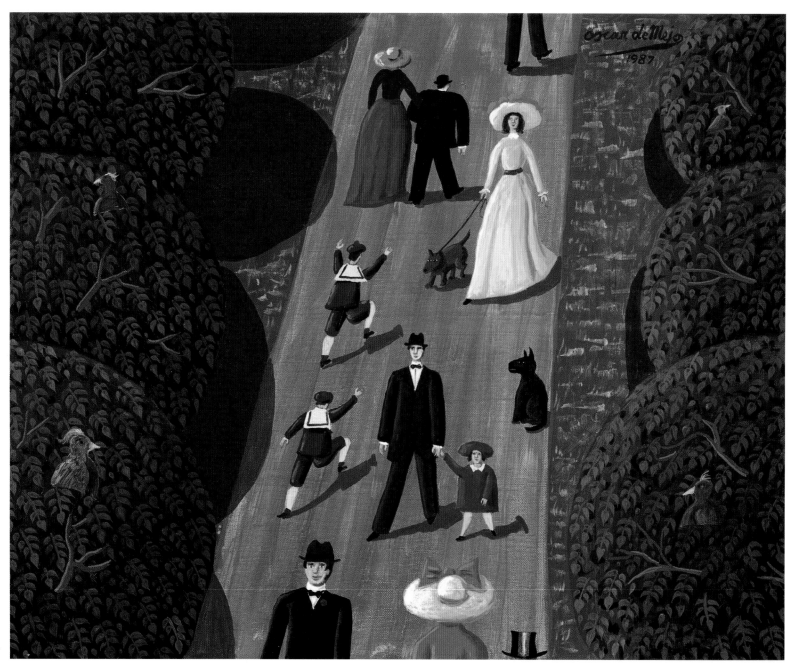

THE STROLL IN THE PARK *1987. Canvas, 16 x 20".*

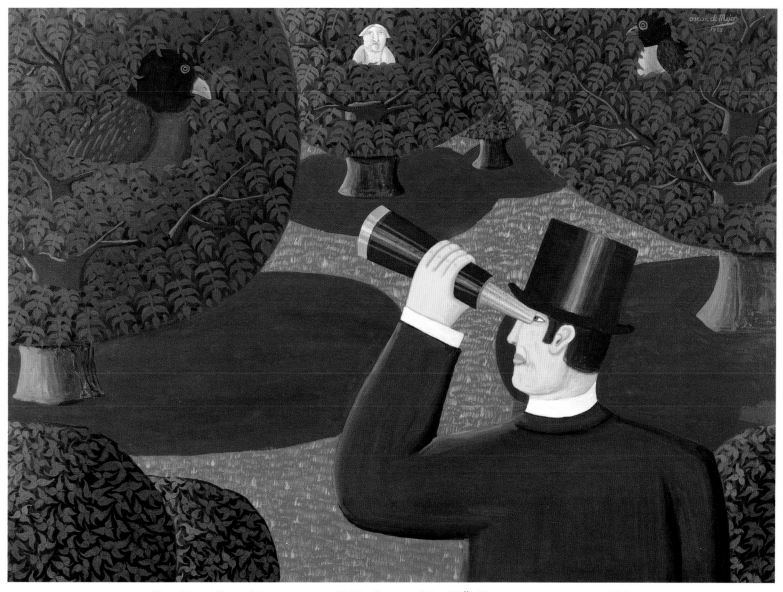

THE TWO BIRD WATCHERS *1988. Canvas, 36 x 50". (See commentary page 138.)*

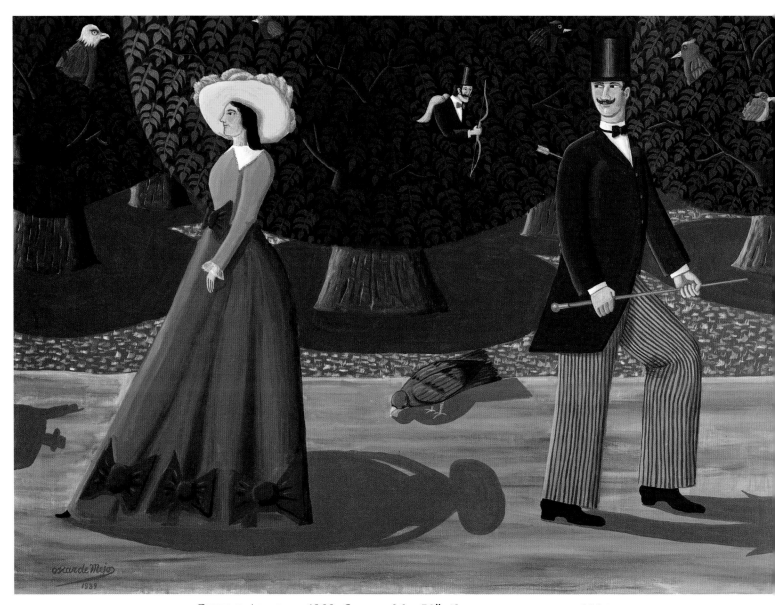

CUPID'S ARROW 1989. Canvas, 36 x 50". (See commentary page 138.)

PEARLY GATES *1982. Canvas, 36 x 26". Private collection.*

THE ASTRONOMER
1987. Canvas, 16 x 20". Collection Mickey and Janice Cartin.

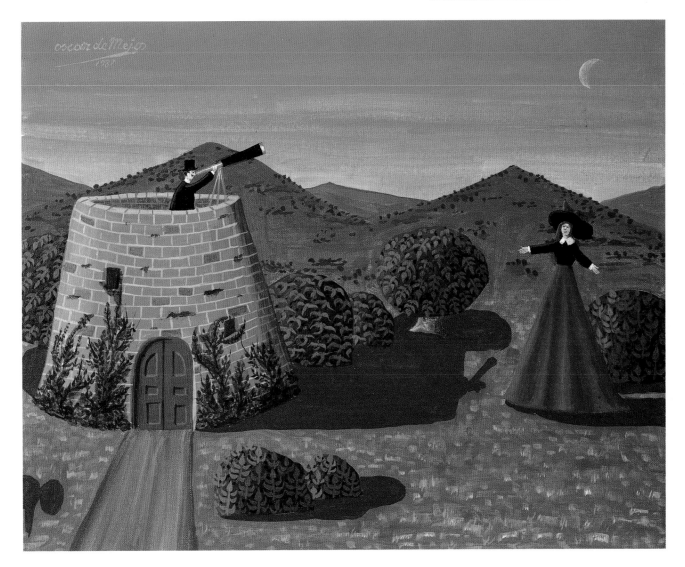

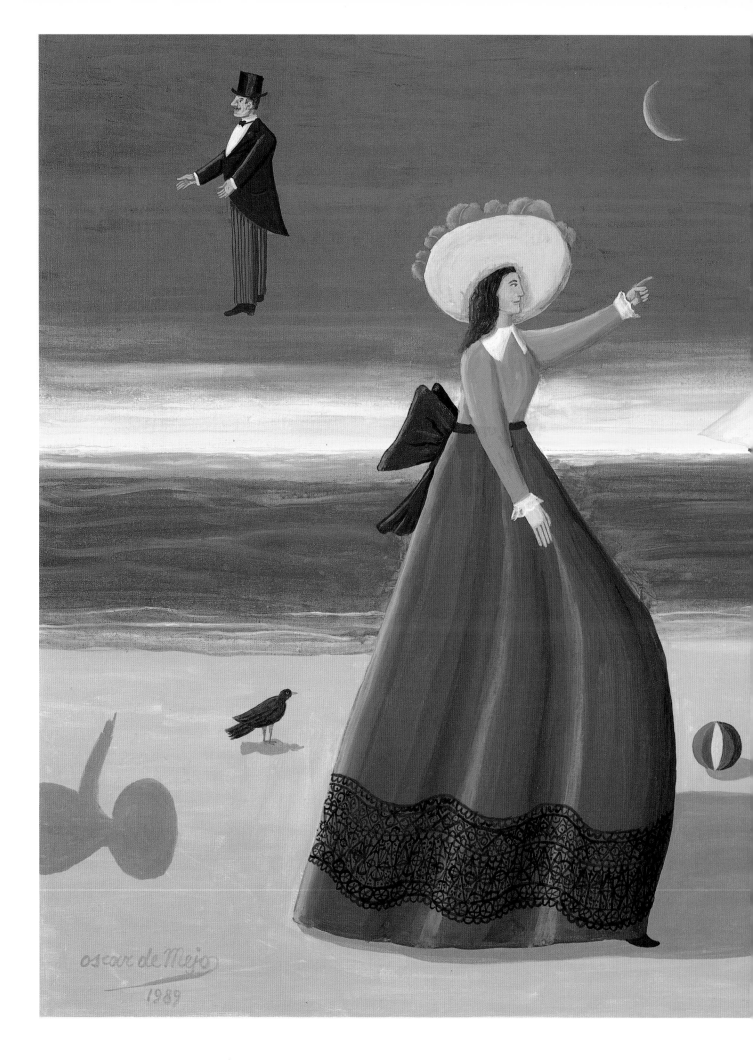

THE MARVELS OF SCIENCE,
A DOUBLE MIRAGE
1989. Canvas, 30 x 40".
(See commentary page 138.)

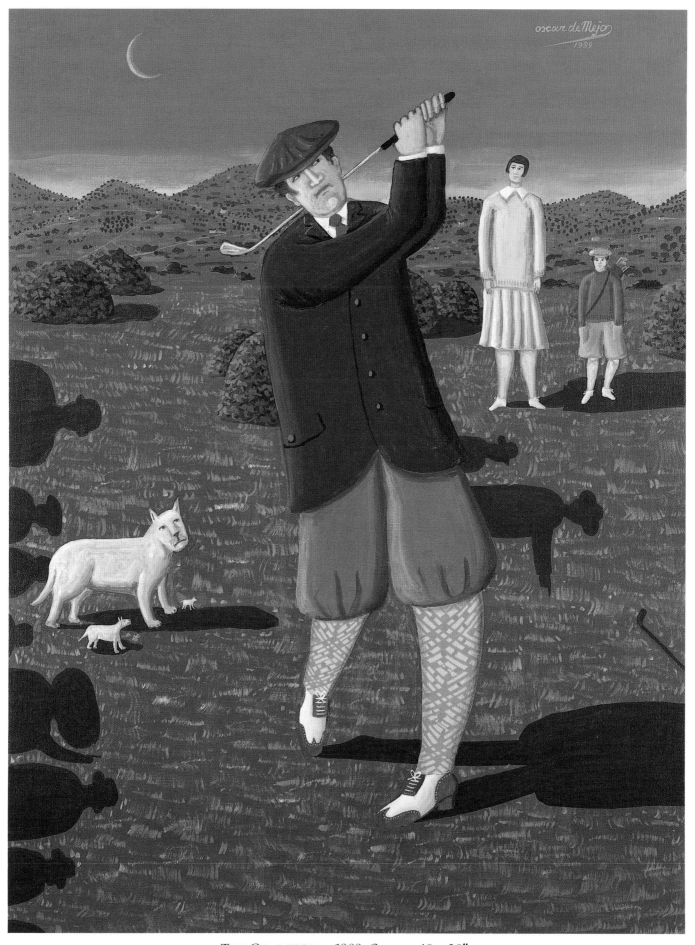

THE CHAMPION *1989. Canvas, 40 x 30".*

CHAMPIONS AT THE NET
1988. Canvas, 26 x 34".

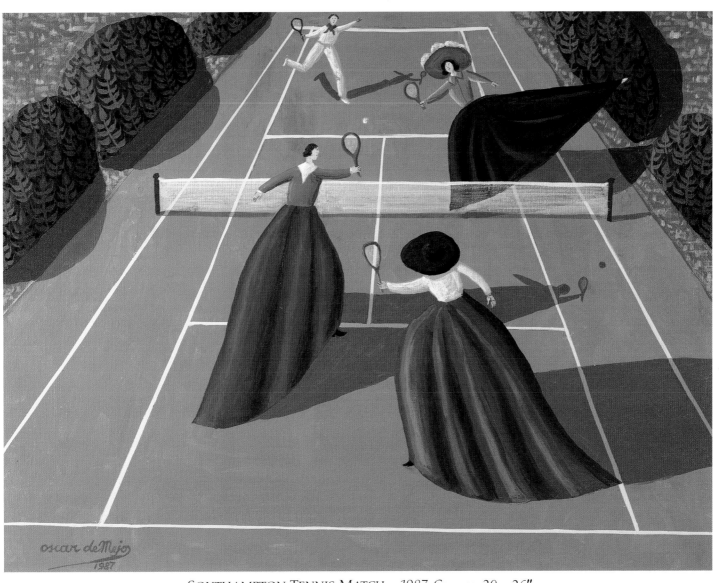

SOUTHAMPTON TENNIS MATCH *1987. Canvas, 20 x 26".*

WASHINGTON IN THE TRENCHES OF YORKTOWN
1982. Canvas, 26 x 36".
Collection Agnes Virginia de Mejo.

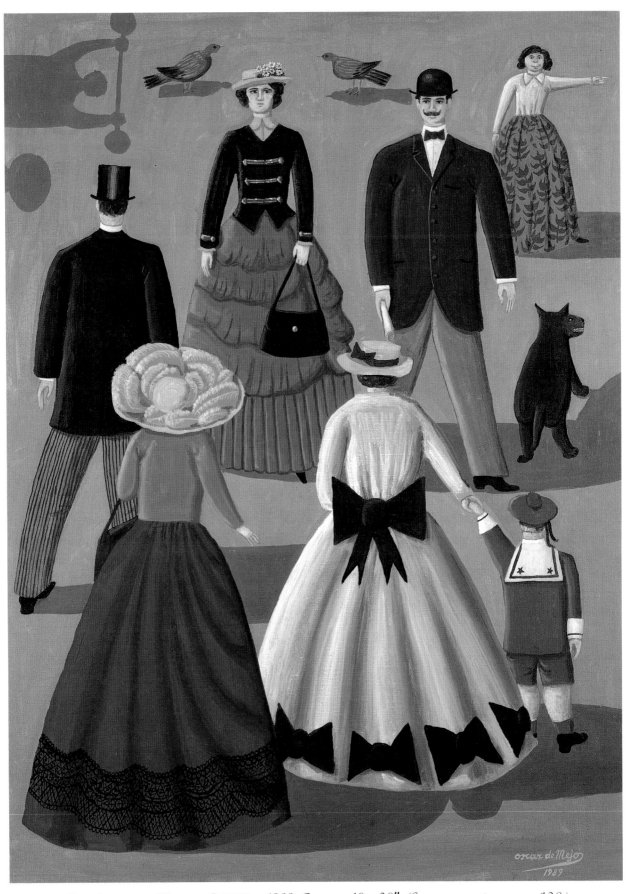

THE SNUBBED WEIGHT LIFTER 1989. Canvas, 40 x 30". (See commentary page 138.)

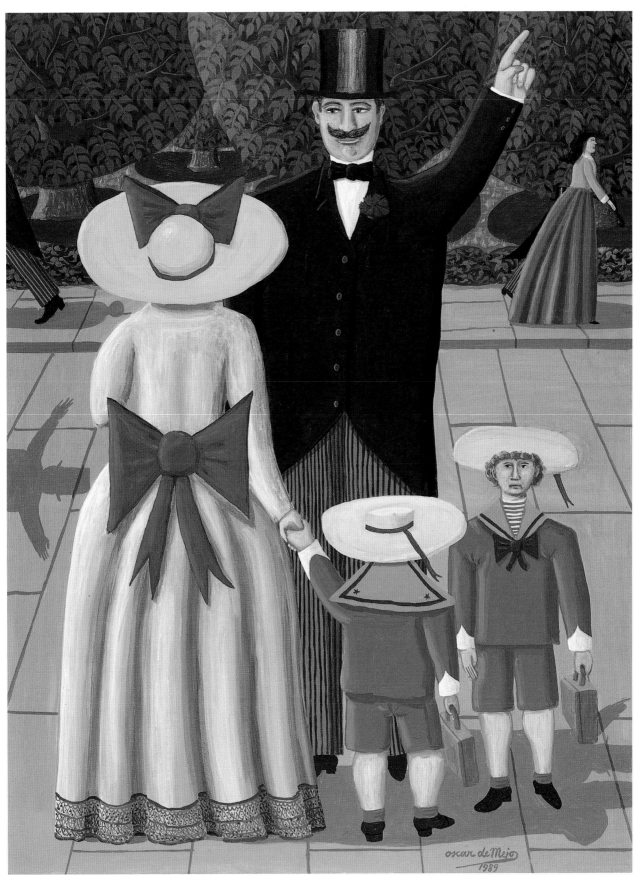

THE ENCOUNTER 1989. Canvas 40 x 30". (See commentary page 138.)

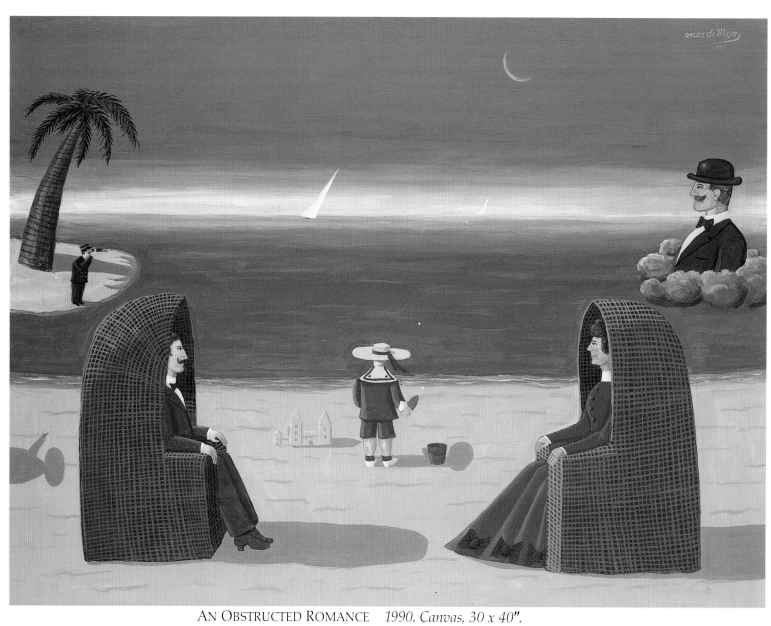

AN OBSTRUCTED ROMANCE *1990. Canvas, 30 x 40".*

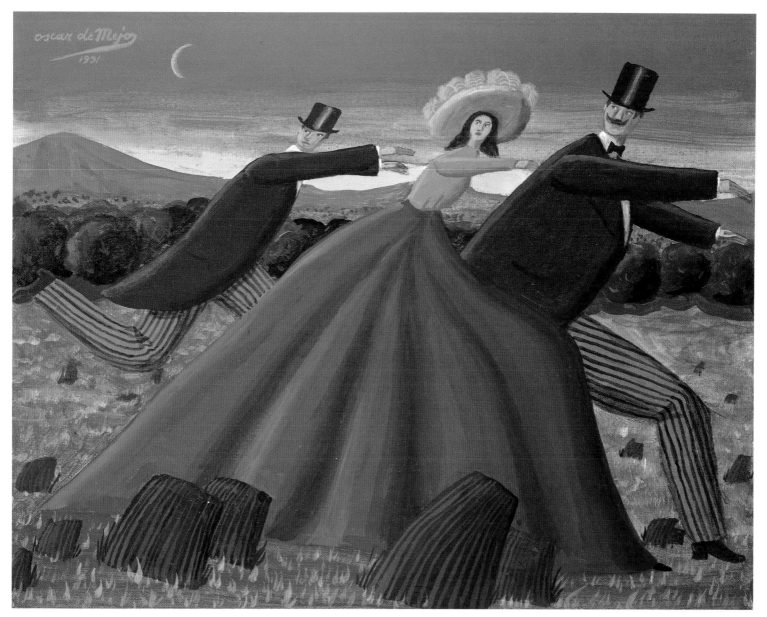

THE FLIGHT *1991. Canvas, 14 x 18".*

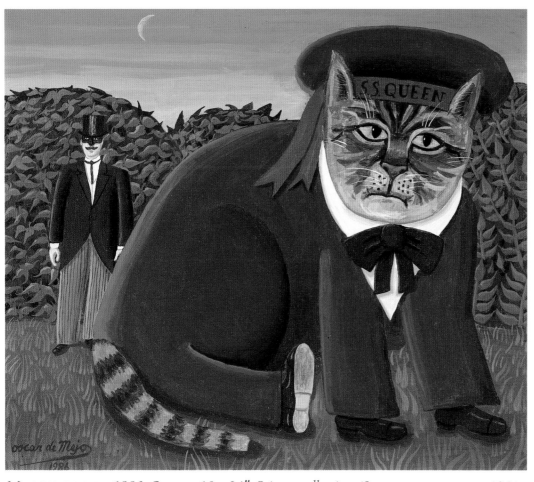

MASQUERADE *1986. Canvas, 18 x 24". Private collection. (See commentary page 138.)*

CAT GOES TO A MASKED BALL *1991. Canvas, 18 x 24". Private collection.*

THE BEACH AFICIONADOS *1991. Canvas, 36 x 50". Collection Marsha and Michael Dayan.*

THE BETROTHED *1990. Canvas, 50 x 36".*

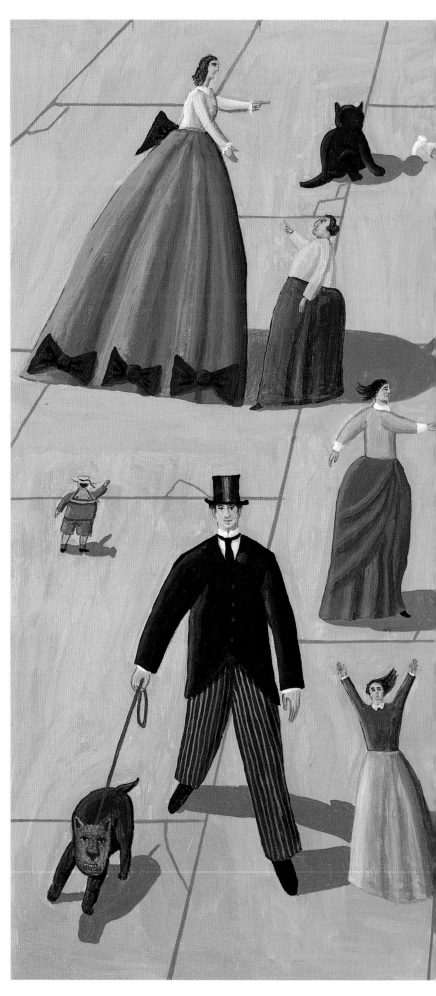

BUSY PHILADELPHIA SQUARE
1989. Canvas, 24 x 36".
Collection Sue and Richard Pieper.
(See commentary page 139.)

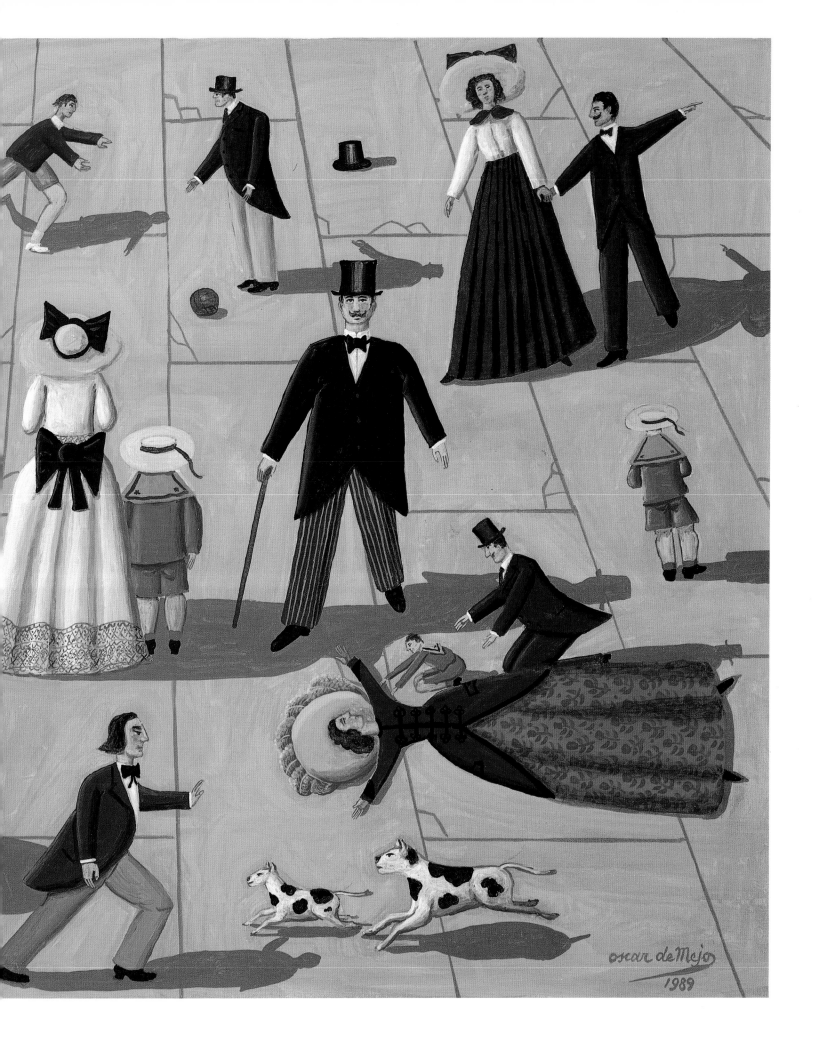

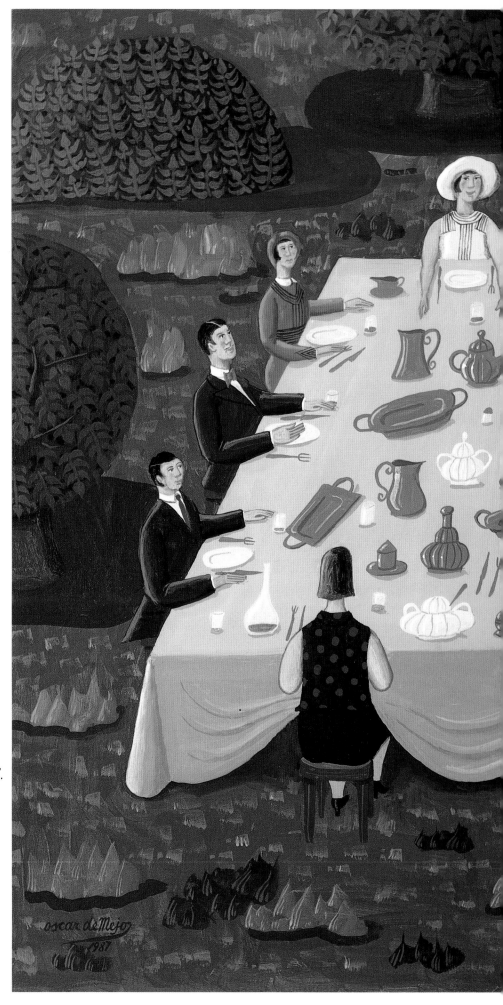

LATE ARRIVALS *1988. Canvas, 36 x 50".*

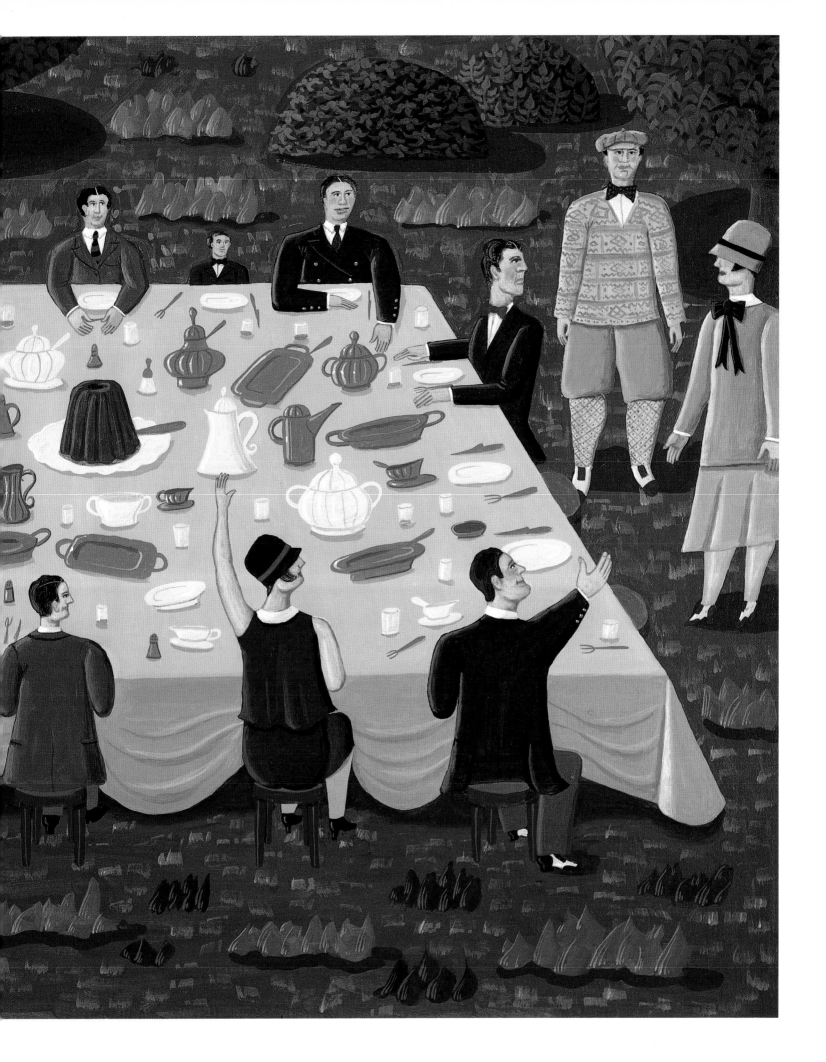

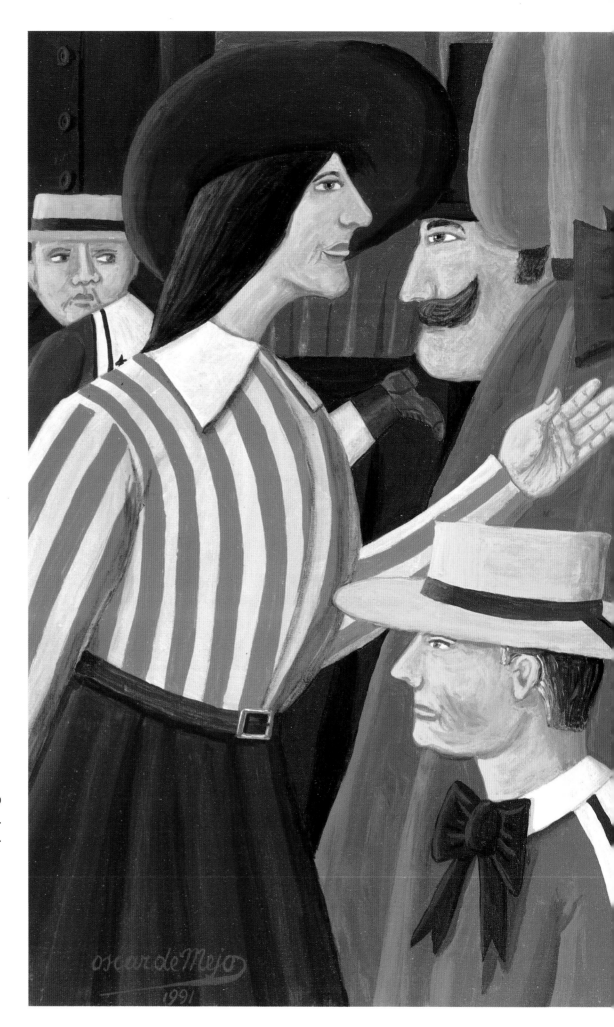

THE CROWD
1991. Canvas, 26 x 36".
Collection of the artist.

104

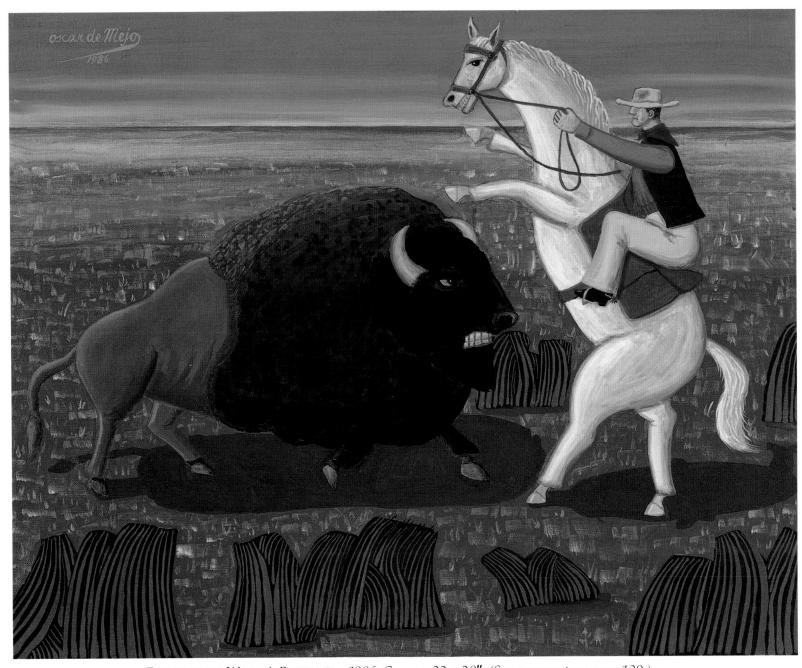

ENCOUNTER WITH A BUFFALO *1986. Canvas, 22 x 28". (See commentary page 139.)*

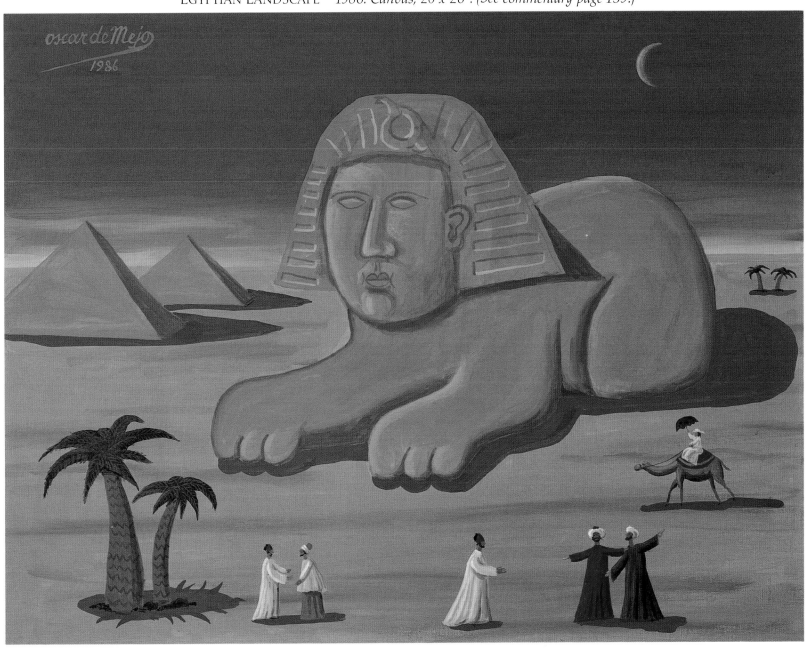

EGYPTIAN LANDSCAPE *1986. Canvas, 20 x 26". (See commentary page 139.)*

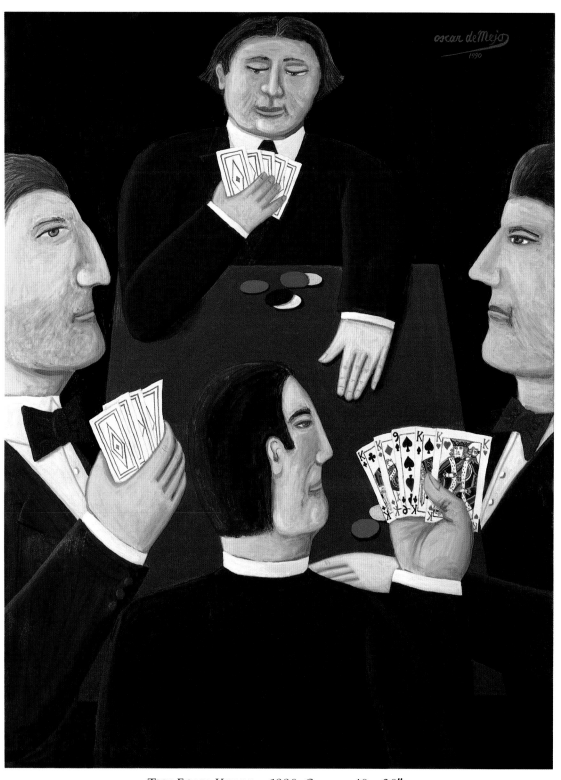

THE FOUR KINGS *1990. Canvas, 40 x 30".*

A SLIGHT MISUNDERSTANDING IN THE CARD GAME
1988. Canvas, 36 x 50". Collection Stanley Zinberg. (See commentary page 139.)

EUTERPE AND JAZZ PERFORMERS
1984. Canvas, 26 x 36". Collection Dorothy de Mejo.

110

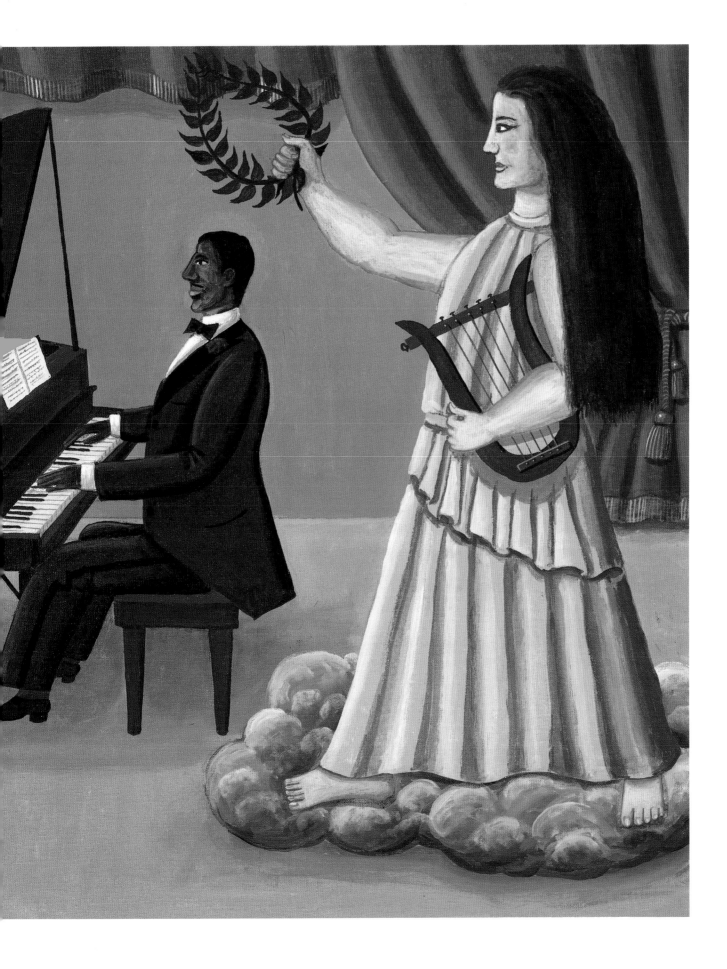

THE MAN OF DESTINY
1972. Masonite, 26 x 36".
Collection Ermanno Mori.
(See commentary page 139.)

THE SLAP IN THE FACE
1987. Canvas, 36 x 50".

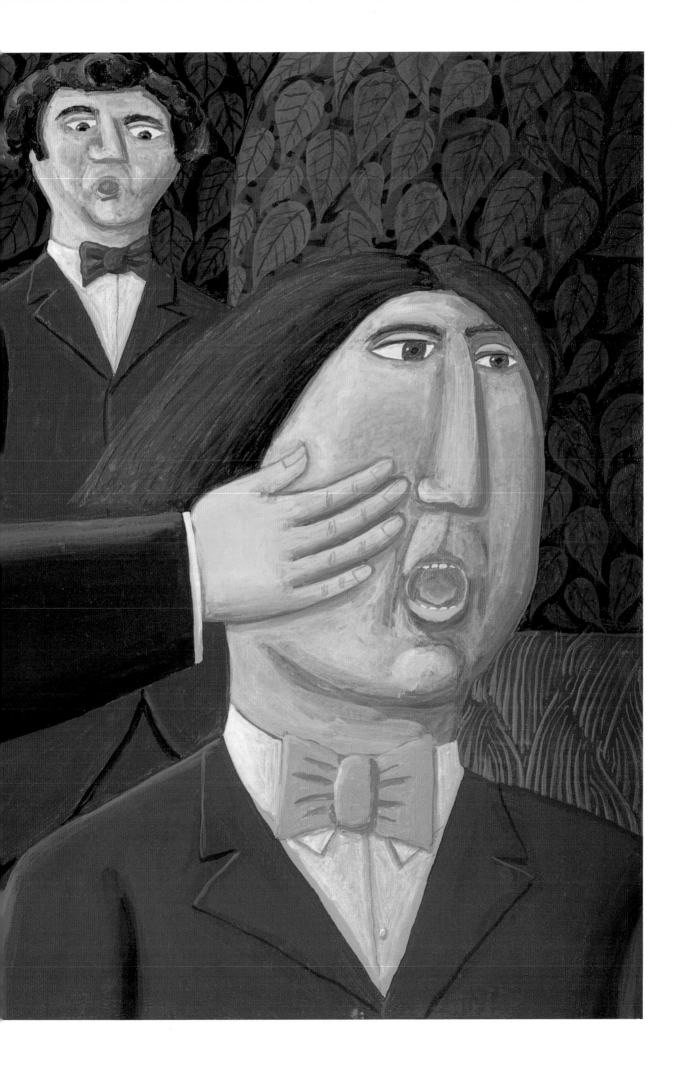

OMAHA COEDS, 1924 *1985. Canvas, 38 x 48". Private collection.*

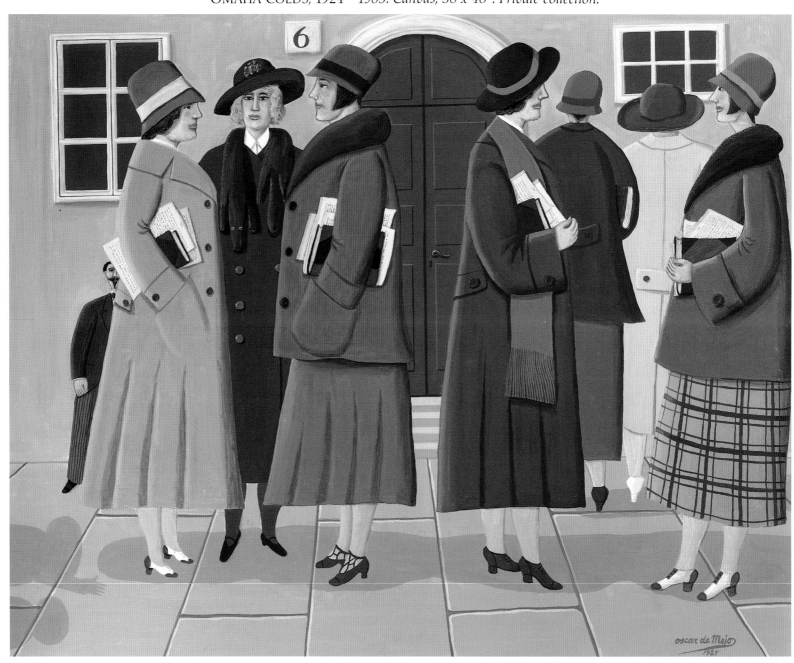

BIG CITY BLUES *1986. Canvas, 36 x 50". Private collection.*

PROFESSOR OF ETIQUETTE
1983. Canvas, 26 x 50".
Collection of the artist.

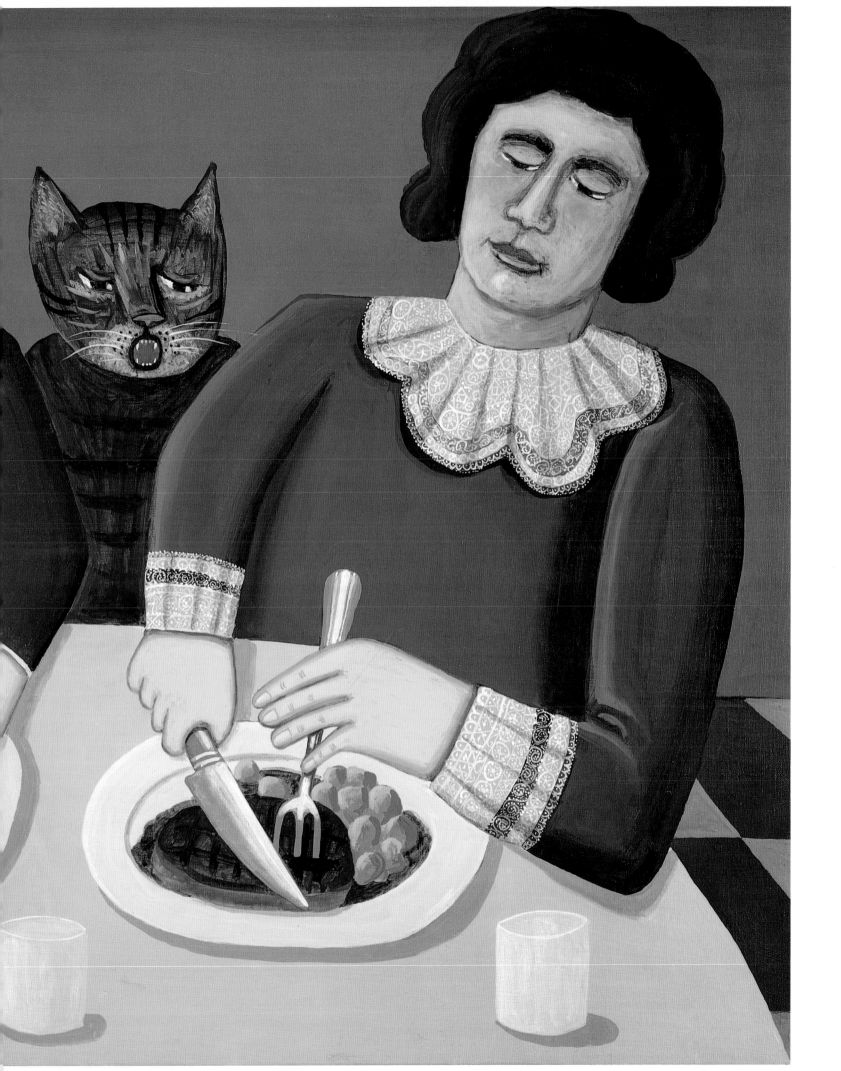

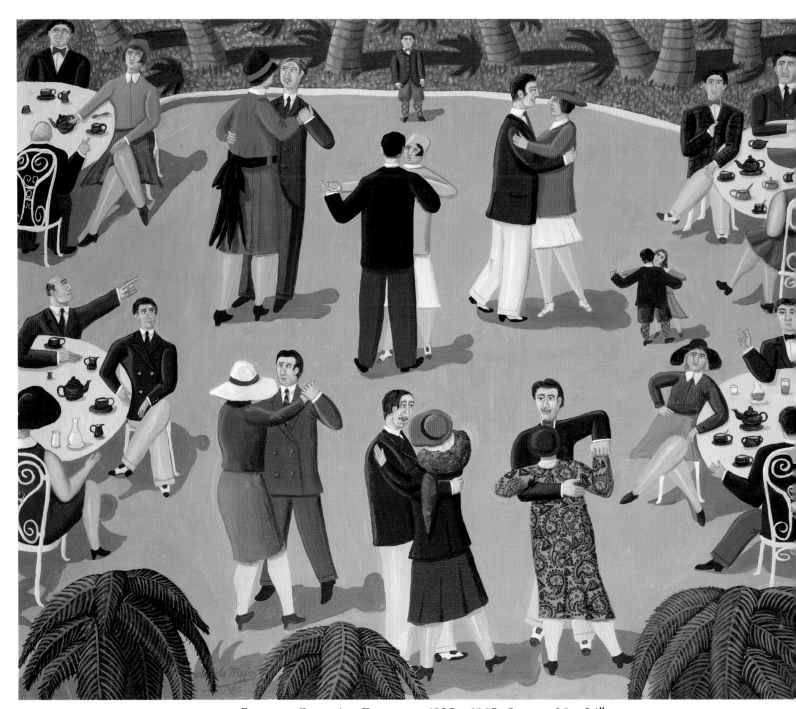

FLORIDA OPEN-AIR DANCING, 1925 *1985. Canvas, 28 x 34".*

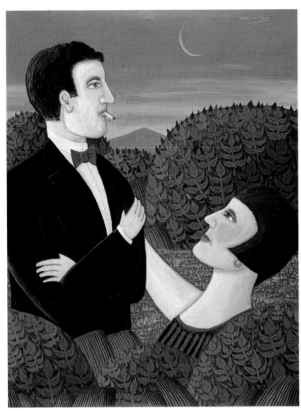

THE IDOL *1989. Canvas, 40 x 30". (See commentary page 139.)*

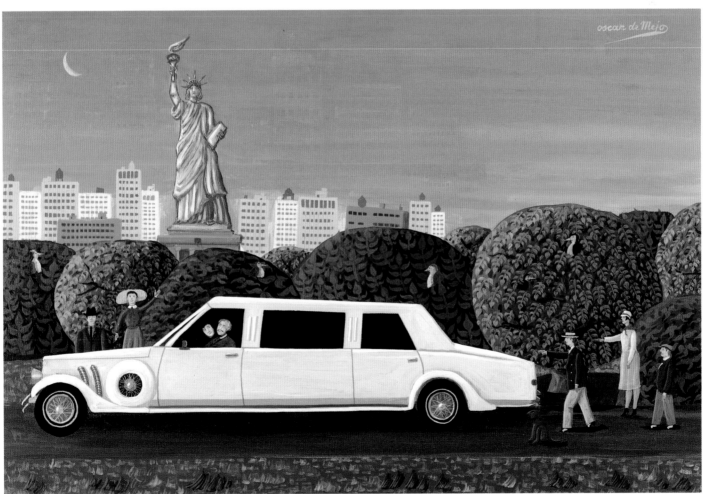

THE LIMO *1988. Canvas, 24 x 36". Collection Empire Coach.*

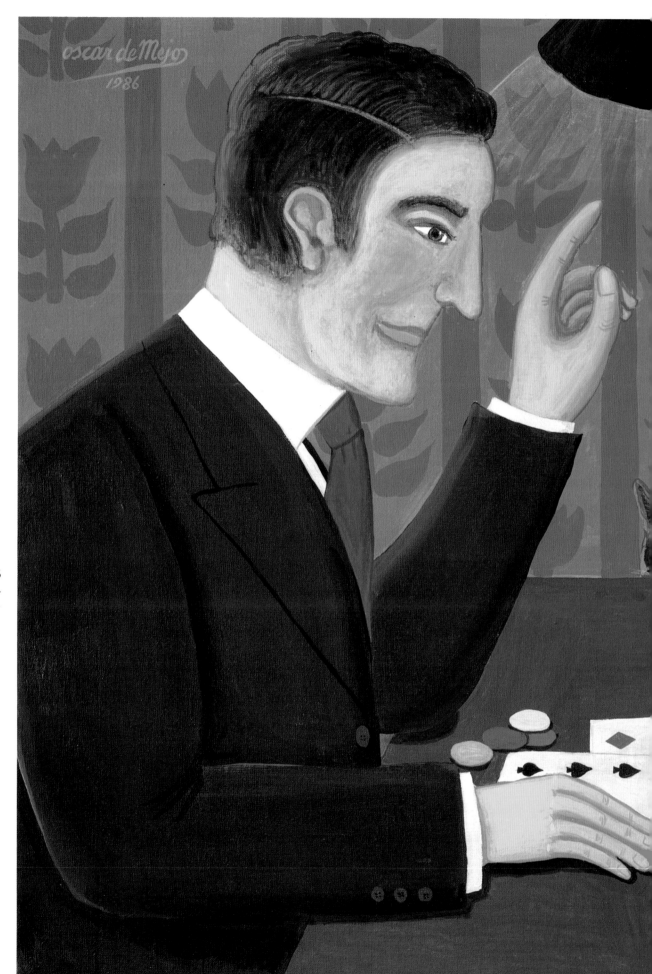

KING OF HEARTS
1986. Canvas, 24 x 36".
Private collection.

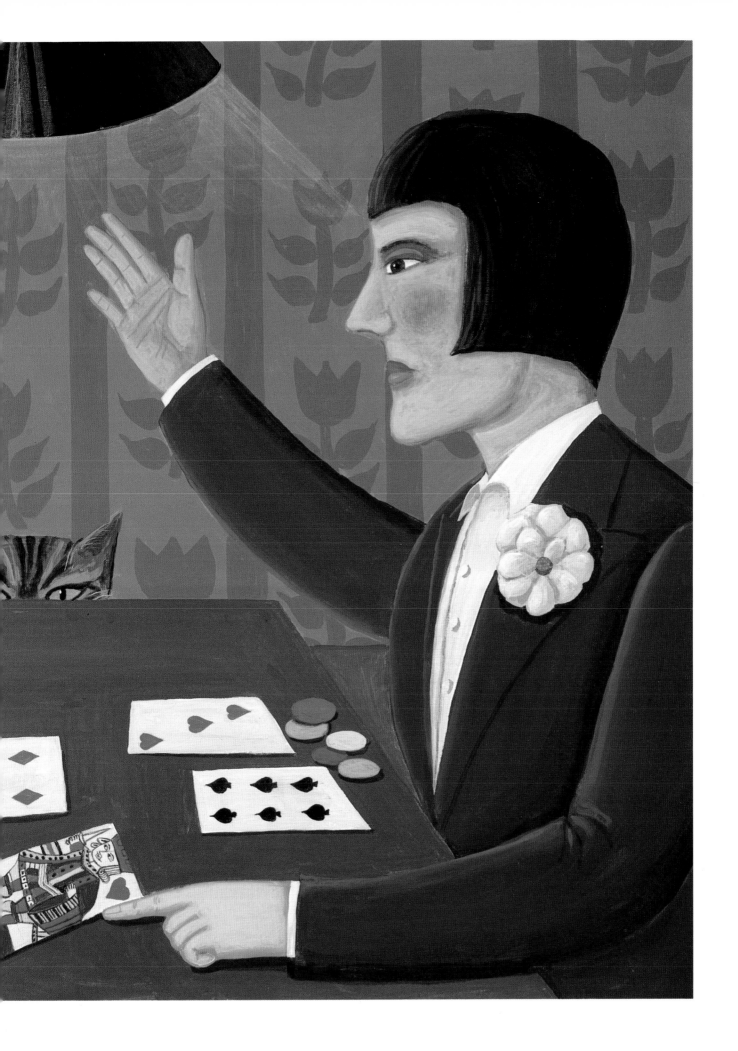

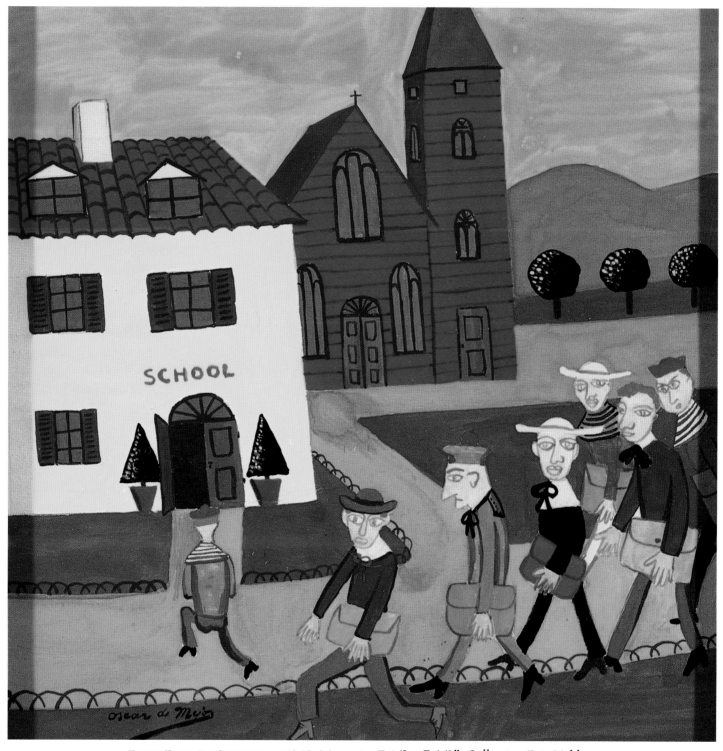

FIRST DAY AT SCHOOL *1949. Masonite, 7 1/2 x 7 1/2". Collection Eric Nebbia.*

THE WEDDING *1949. Masonite, 7 1/2 x 7 1/2". Collection Eric Nebbia.*

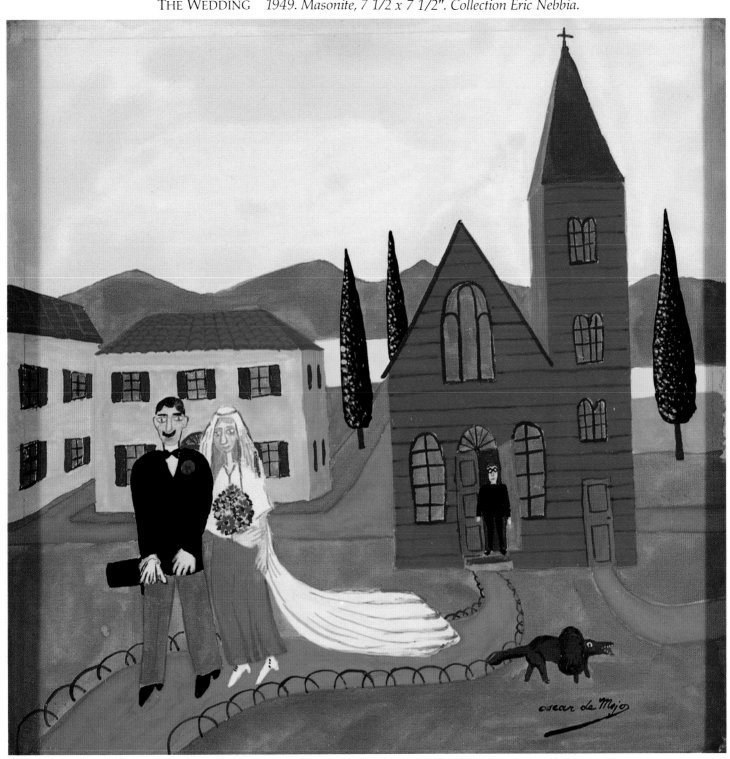

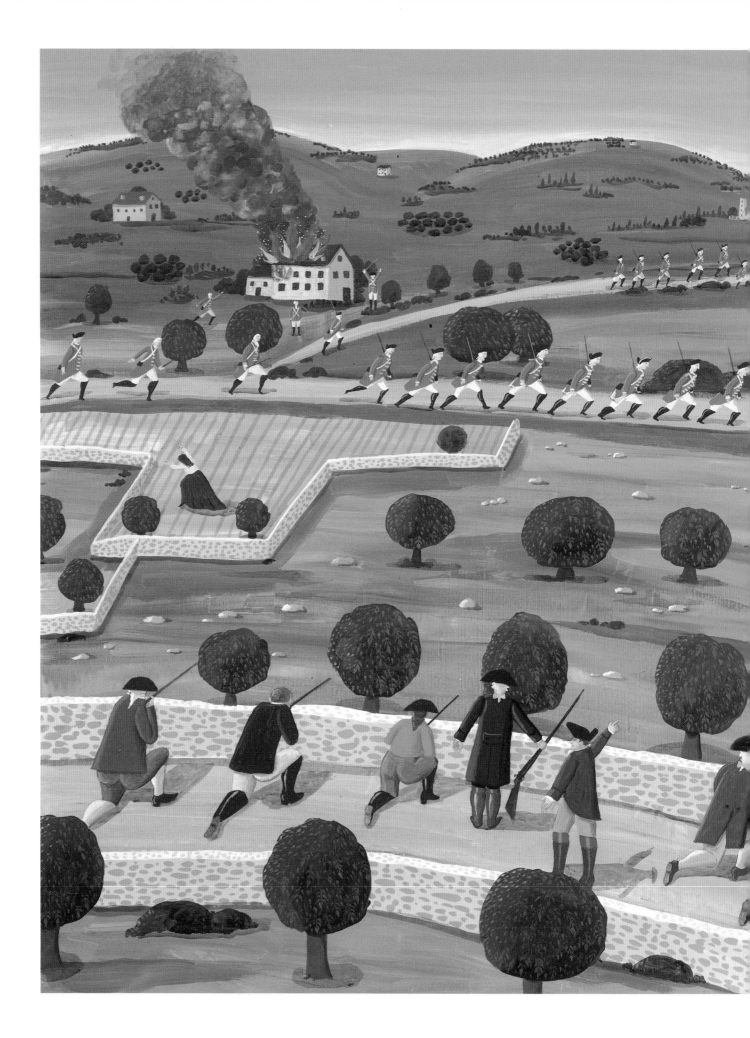

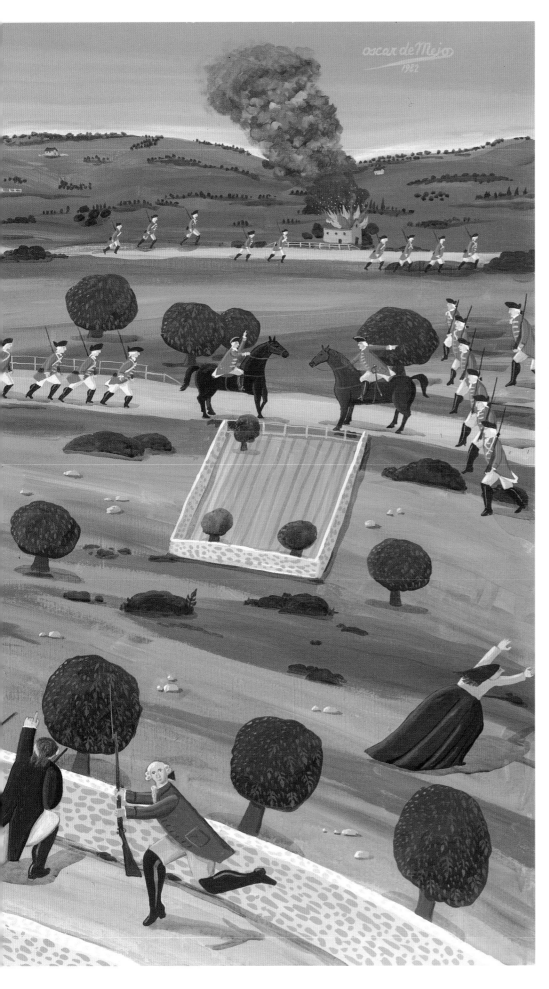

INCIDENT AT LEXINGTON
1982. Canvas, 36 x 50".
(See commentary page 139.)

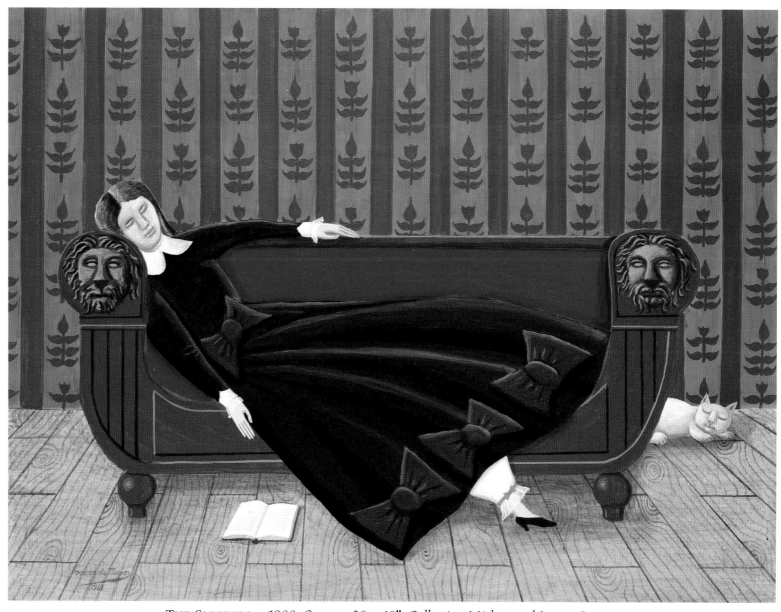

THE SLEEPERS *1988. Canvas, 30 x 40". Collection Mickey and Janice Cartin.*

YORKTOWN VICTORY BANQUET *1989. Canvas, 36 x 50". (See commentary page 139.)*

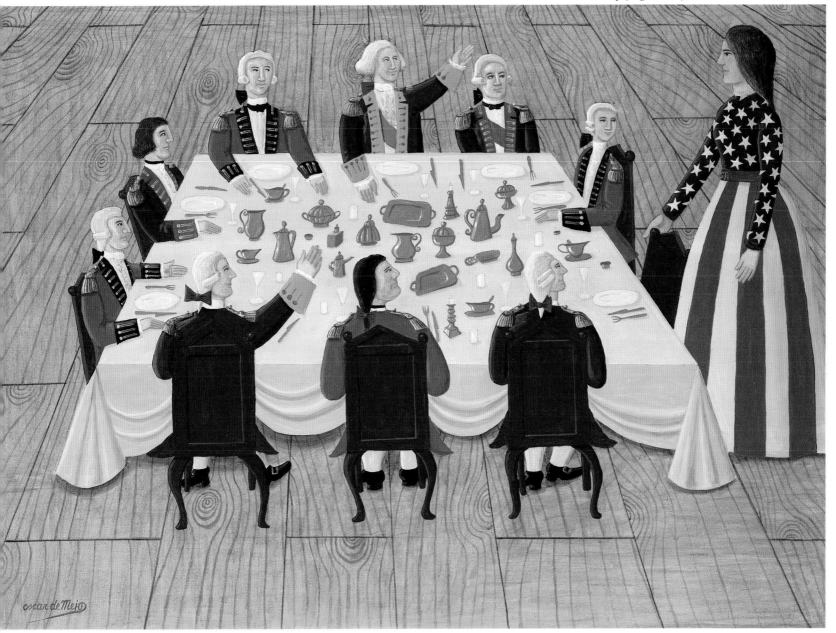

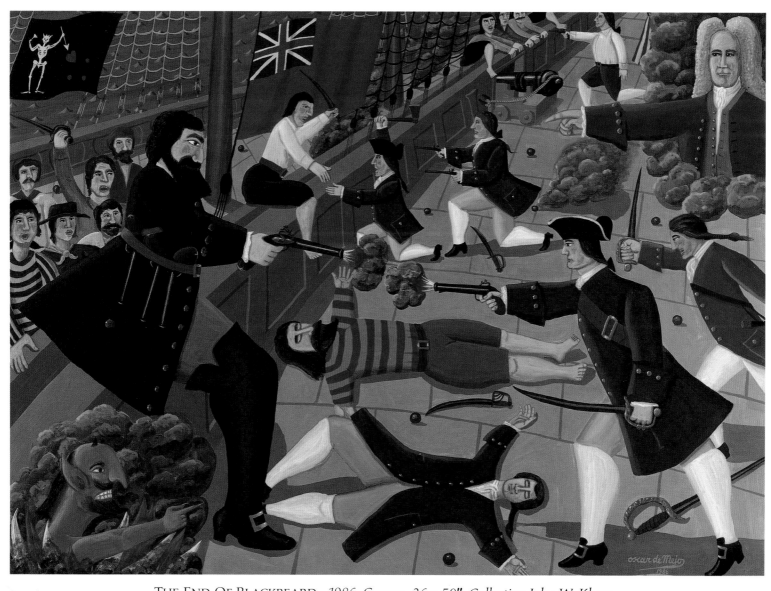

THE END OF BLACKBEARD *1986. Canvas, 36 x 50". Collection John W. Kluge.*

WASHINGTON'S INAUGURATION II *1983. Canvas, 48 x 68". Aberbach Fine Art.*

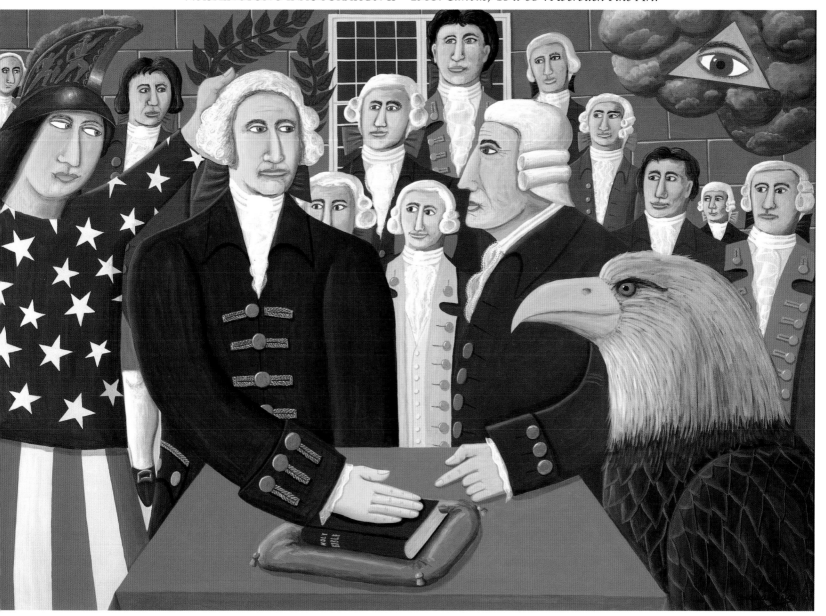

FEROCIOUS DOG INTERRUPTS OUTDOOR
DANCING PARTY
1991. Canvas, 26 x 36".

JESUS VISITS NEW YORK
1957. Masonite, 26 x 36". Collection Ermanno Mori.

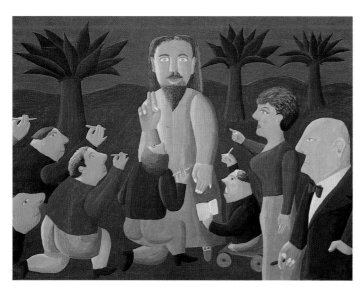 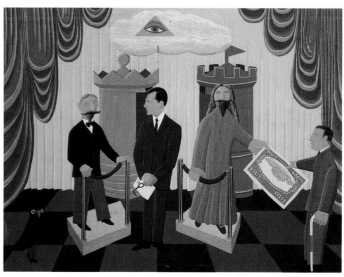

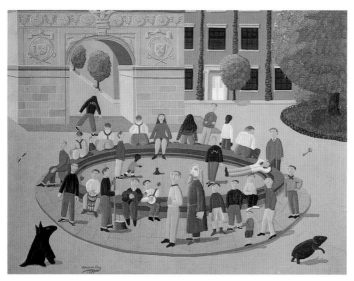 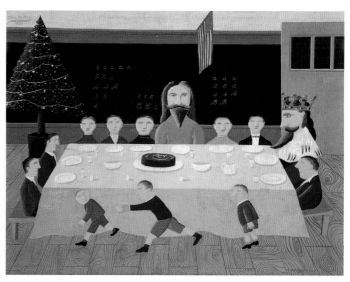

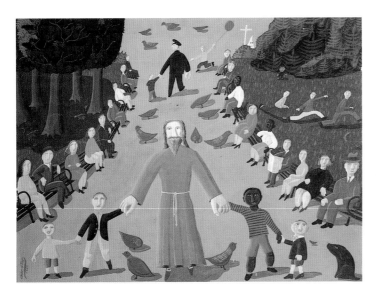

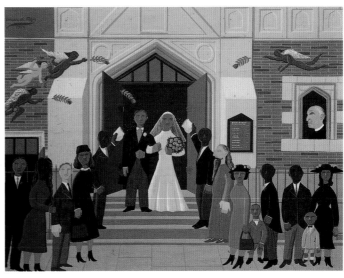

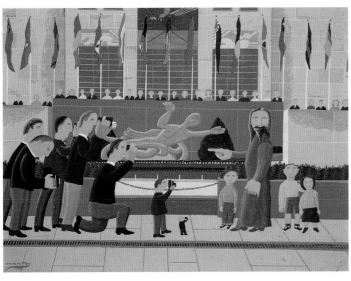

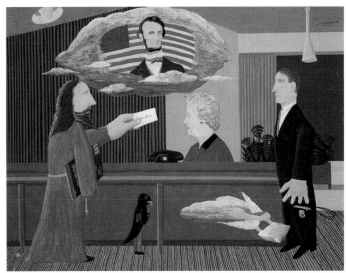

BY OSCAR DE MEJO

pages 14, 15

AMERICANS ON THE ILE DE FRANCE

These five Americans–five of the New York "four hundred" –blasé as they are, look with fascination at the horizon where the tall buildings of Manhattan are disappearing in the mist. They are sailing on the *Ile de France* on her maiden voyage to Le Havre (1927). The little man in the center is not supposed to be there. He is Mario Bassotto, who is planning to travel to his native Italy via France. His third-class ticket did not prevent him in his adventurous ways from paying a brief visit to first class. Now he is ready to go back to the lowest bridge of the ship where his cabin for four is located.

page 16

THE TINY SUITOR

Angela McGrath is now thirty-five and still not married. After hearing her mother's daily complaints, she realizes that the time has come for her to take the momentous step. Among her many suitors (bear in mind that Angela has inherited from her father a flourishing toothpick empire) is tiny Sir Romildus Billingsley Nostradamus. This gentleman has been paying court on Angela with touching regularity, and many times he has confessed he would like to take her to the altar. But she won't commit herself. Is her reluctance due to his diminutive stature? Not in the least. She would love a tiny husband she could dominate completely. What really bothers her is his baldness. So he pledges he will buy a wig if she will marry him. "No," she says. And that is that.

page 19

THE CHAMPS

They are both great champions, but one is a real boxer, the other is a brawler; one fights clean, the other fights dirty; one is good, the other bad. The irony here is that an extremely absentminded devil by the name of Astarot has chosen to help the good guy instead of the bad guy win the championship.

pages 20,21

I CALL THIS LAND VIRGINIA

Walter Raleigh's men land on Roanoke Island. Foreground, left to right: Captain Arthur Barlow; Captain Philip Amadas; Navigator Simon Fernandez; and a sailor. Center background: Walter Raleigh, who sent the expedition to America. He was not part of it because the Queen, deeming the voyage too dangerous, forbade him to go. The Queen is present, of course, for having given the go-ahead. Upper left-hand corner: Humphrey Gilbert, a relative of Raleigh's, who had led an earlier expedition for him–and perished at sea.

page 24

AMERICAN HORSE RACE, 1783

The drama here is not so much in the center of the picture (who's going to win the race?) as it is in the upper right-hand corner where you see Lady Sybil Furthermost, the grande dame of Louistown, and the R.H. Joseph Mattinello.

The fact is that to be a grande dame is one thing but a huge dame is another–especially if your husband is a tiny little man. When in public, Lord Furthermost (man in black, upper center), not to look so small, avoids standing near his wife, and this regularly breaks her heart.

pages 26, 27

THE MIRAGE

One perennial discussion between Theresa McIntosh and her brother (shadow on the left) concerns mirages and whether they are a phenomenon that really exists or are just a figment of the imagination of certain scientists who travel in the desert. Theresa sustains that on hot days the phenomenon really happens and now, lo and behold, thanks to the torrid temperature of the day, she can show her brother *two* Uncle Leos, one enjoying a serene snooze in his chair on the beach, the other suspended in midair, quite nervous to be fifty feet above terra firma.

page 30

THE POET AND HIS MUSE

John Mirabello, the poet, is accustomed to taking a siesta in the wood after lunch. One of the reasons for this is that when he sleeps his muse–in the form of a bird–visits him. The bird has a lovely voice and recites beautiful poems; the poet, who is endowed with little talent but a strong memory, learns them by heart. Now you know why John Mirabello passes for a good–some even say great–poet.

page 36

LIBERTY OR DEATH

The painting depicts Patrick Henry delivering his famous speech in Richmond, Virginia, at St. John's Church on March 23, 1775. His words, "Give me liberty or give me death," thrilled the crowd and precipitated the rebellion in Virginia. The slogan "Liberty or Death" was used on the flag of the Hanover Association during the Revolutionary War.

The figure that has materialized is an early volunteer of the war. He hasn't been issued a uniform yet, so he wears his hunting cloth. Incidentally, there is tiny man in green on the Hanover Association flag.

page 39

MEETING WITH GEORGE

The two great admirers of George Washington here depicted often stop in front of his portrait on the vase and talk to the Father of the Land. What they talk about is not known. However, it is said that Great George sometimes participates in the conversation with a precise "yes" or "no."

THE UNCLE IN THE MUSEUM

Madame Sylvester, a widow from Cincinnati, Ohio (the lady in the purple skirt), regularly brings friends to the museum to see the statue of her uncle, Leo Le Bonnet, who was quite a speaker in his time. His famous "We are not to blame" speech, delivered in 1887 at the National Convention of Watchmakers, is still remembered with awe by the elderly.

Here, the visit to the museum takes place under special circumstances. The two gentlemen Madame Sylvester has brought with her are Master Aloysius McFarlane and his father, Lord Simple McFarlane, of Bath, both on a brief tour of the city. It is whispered that the McFarlanes are very rich and young McFarlane is in the market for a wife.

The girl on the right is Bonnie Sylvester, the only one of her nine daughters for whom Madame Sylvester has been unable unable to find a husband. Her scheme is to impress young Aloysius with the glories of her family so as to convince him to marry seventeen-year-old Bonnie. Her desire is so intense that her dear departed uncle has materialized and apprehensively surveys the scene.

WALL STREET SECRET MEETING

The meeting was the idea of John Langwood (gentleman in the center), a Wall Street broker–quite unsuccessful, I might add–who decided to do something to attract attention to himself and the Langwood, Langwood, and Langwood brokerage firm. One morning he summoned to his home a number of relatives, dressed them like proper businessmen, and asked them to attend a secret meeting at 6 o'clock that same day in Julius Park near Wall Street. He promised them an earth-shaking announcement. Then he leaked news of the secret meeting to the press. Since the press had never before heard of a business meeting held in a park, some journalists decided to attend.

The earth-shaking announcement delivered by John Langwood that evening was to the effect that one new member was joining the board so the firm's name from then on would be Langwood, Langwood, Langwood, and Langwood. After asking his partners to keep the news secret, John Langwood bowed to the applause that followed, and the meeting came to a close.

The secret meeting in Julius Park became the talk of Wall Street and the Langwood firm the talk of the town.

COUP DE FOUDRE

While grandfather explains to the young boy all about lightning and how Benjamin Franklin was almost incinerated when he discovered the lightning rod, Baron Almavia tells his pretty Baroness that that was exactly the way it was when he first met her–a coup de foudre.

THE TOAST

The Society for an Everlasting Tribute to Poetry summoned its members to its headquarters in Buffalo for "an extremely important announcement." Those very words were used by the president of the society, the Right Honorable Similar B. Snowdon, in a formal invitation sent to the seventeen members of the institution.

At the gathering, which started with the usual dinner featuring all kinds of splendid food, President Snowdon stood up, raised his glass, and said, "Dear fellow poets, it is with great emotion that I…." What followed was a speech that lasted an hour and a half, and I report here only the gist of it: To thunderous applause, Similar B. Snowdon suggested they change their name to the Society of Impenitent Gourmands and be dedicated entirely to the glorification of good food and chocolate cake. The acceptance was unanimous, and the program was to have twelve meetings a year in the form of Lucullan banquets to be held at the society's headquarters. The only objection came from tiny Sir Mortimer L. Dorado (right foreground), who wanted the meetings to be held twice monthly. His suggestion was applauded enthusiastically and its variation accepted by all members ipso facto.

THE HAPPY SKATERS

This hotel facing the little lake of Bulwer Lytton in Vermont is the winter headquarters of The Harder We Fall, a club for skating enthusiasts. The name of the club comes from the motto they use to explain their philosophy: "The harder we fall, the better we feel." In order to demonstrate the soundness of the motto, the members skate with a vengeance, never giving thought to the possibility of falling flat on their faces. The staff of the hotel includes four doctors, twelve nurses, and a chef de cuisine who specializes in food for convalescing patients.

THE BIRD LOVER

Ever since he was a child, the Earl of Knots-Barberini loved birds. He is considered the number-one bird lover in the world and spends several hours a day up a tree among his winged friends. Several renowned ornithologists have commented on this habit and have stated that the Earl has initiated something entirely new in the study of birds. It is a fact that in consorting daily with sparrows, larks, doves, owls, hummingbirds, and swallows, the Earl has attracted some never-before-seen birds. Commenting on this, the nobleman has said, "Yes, there are among my feathered friends some new flying creatures. One of them could even speak several foreign languages and taught me Russian. Now I can take a trip to Moscow and visit my friend Czar Nicholas."

page 67

THE GAME OF POKER

At the New York flat of the King of Hearts, a high-stakes poker game is in progress. The players are the King, the Queen, the Jack of Diamonds, and the Jockey. To the great disappointment of the King, who has a straight flush in his hands, the Jockey has left the table to go to the bathroom.

page 68

CUPID IN THE PARK

Cupid is pleasantly surprised not because his arrow has struck, but because the target of the shot, a notorious anti-feminist and sworn bachelor, is just about to propose to Annie Wilkins, a young woman from Bismark, South Dakota. You know, of course, that Cupid himself is from South Dakota. This fact made him twice as pleased to have aimed correctly.

page 80

THE THREE TALL SISTERS

The three tall sisters were born in Bismarck, North Dakota, the daughters of General Achilles McDougal Camp (retired). Priscilla, Mabel, and Norma Louise, all in their late twenties, are unhappy to be so tall but managed to find husbands. Mabel (center) regretfully lost hers three months ago and is still partially in mourning, but the other two are happily married. In the case of Mabel and because of her huge proportions, a story circulated when her husband passed on that she was "too much for him." A mean comment. But then–oh tempora, oh mores!

page 81

THE LITTLE SPY

The little spy is Jonathan Wethergood, who, for some reason as yet unclear, has a chip on his shoulder against humanity. Here he is spoiling Gwyneth's favorite game of hide-and-seek by revealing to her prematurely where her husband is hiding.

page 83

THE TWO BIRD WATCHERS

Democrates Smith, the bird watcher from Medford, Oregon, uses for his favorite pastime the telescope which his grandfather used when traveling the South Seas. Now please don't think for a minute that the being hiding in the tree is a white dove. That is Jim Turtle Avis, who claims that there is no better technique to study birds than living among them disguised as a bird. With masterly applied makeup, he has chosen the appearance of a dove.

page 84

CUPID'S ARROW

Among these dramatis personae, the most important one is undoubtedly the fellow whose shadow you see on the left-hand side. He is the president of the Bachelor's Forever Society, and he is frantically trying to warn his friend George Smith Bailey that Cupid has him in his sights. Too late. Cupid's arrow finds its mark, and George falls madly in love with Rose Budd, whom he is setting eyes on for the first time.

pages 86, 87

THE MARVELS OF SCIENCE, A DOUBLE MIRAGE

Everyone is familiar, I'm sure, with mirages, the optical phenomenon that creates the illusion of objects on terra firma to be also present in the sky. It occurs, scientists say, mostly in the desert on very hot days.

Well, here we have, wonder of wonders, a double mirage in one of its rare occurrences. Roseanne Margitone, a housewife from Miami, Florida, was spending a peaceful day at the beach with her husband, Radames, and son, Battista, when the phenomenon happened. Only Roseanne's sister, Mathilda (shadow on left), could notice fully the double mirage. Her comment was interesting and must be reported. "Suddenly I saw three Radames instead of one," said Mathilda, "and the one closer to me, up in the air, looked slightly different. He winked at me in a flirtatious way, blew me a kiss, then disappeared."

page 92

THE SNUBBED WEIGHT LIFTER

People are strolling happily in the square, not a care on their minds. The only unhappy person among them is the weight lifter (shadow on left), who is getting no attention at all in spite of an heroic effort to lift tons of metal. He is also addressing passers-by with loud verbal requests that they look his way. But nobody listens. His wife, Donna Mañana (top right), has a subtle idea. Noticing that the crowd are doing the opposite of what they are asked to do, she invites them to look to her left. Thus, she calculates, they will look to her right and finally notice her husband. Which is exactly what happened.

page 93

THE ENCOUNTER

"As surely as God is up there," says Count Giovanni Sebastianello, grinding his teeth, "if your vicious little devil dares to kick my Boris again, I will fully unleash my anger…."

"And what does that mean?" asks Madame de la Valadier with a sincere curiosity.

"The earth will tremble. The skies will become crowded with black clouds and lightning. The roar of thunder will be deafening. A torrential rain will fall, and a tidal wave will come from the ocean. In other words, IL FINIMONDO!"

pages 96

THE MASQUERADE

The cat is happy. After many years of longing to accompany his master to a masked ball, he is finally going to do it. His master has brought him a nice sailor suit, and the cat has not waited a minute before putting it on. And so tonight–it is anchors aweigh.

pages 100, 101

BUSY PHILADELPHIA SQUARE

Don't think for a minute that these people came to the square punctually at 10.30 A. M. on a Tuesday without a specific reason–each one of them had been summoned there by a letter. The short fat woman with a brown skirt (top left) received, for example, the following message: "Dear Mrs. Strump, Your husband, whom you probably believe to be a model of faithfulness, is nothing but a dirty old man. Details when I meet you." The note went on to give Mrs. Strump the hour and place for the appointment and concluded, "So that you may recognize me I'll wear a purple dress. Yours truly, Mary Betty Whetherly."

Miss Whetherly, who by the way had never heard of Mr. or Mrs. Strump, in turn was summoned to the square by a brief note: "We heard about your recent brilliant graduation, and we would like to talk to you about an executive position with our bank." Her note also stated the time and place of the meeting, but asked her to wear a purple dress. It was signed, "Valery Bottomley, Vice President, the Bank of Bankers, Philadelphia."

The man with the cane (center right) received a perfumed invitation which stated that Anne Barterstock, 23 years of age, had fallen madly in love with him and wanted to meet him in person.

The author of all these mischievous notes is the man in the brown jacket (top center), Mr. Safron Sharonson, whose practical jokes are the talk of more than one town. Incidentally, the lady on the ground, Mrs. Paula Blinkenglitz, has just fainted because she saw a mouse. Nothing serious to be sure.

pages 106

ENCOUNTER WITH A BUFFALO

The ferocious buffalo was getting ready to attack a cowboy and his horse when the cowboy asked, "Hey, haven't we met before." Stunned by the question, the buffalo turned around and left in a hurry.

page 107

EGYPTIAN LANDSCAPE

Top secret! This is the *real* Egyptian sphinx. It is located about twenty-five miles from the one tourists usually visit. That one has a broken nose (Napoleon hit it with a cannonball). The Bedouins do not like to reveal this secret since they want to have the real one all to themselves.

pages 108, 109

A SLIGHT MISUNDERSTANDING IN THE CARD GAME

The hosts of this card game are Theodore Madrigalis (center background) and his brother Sylvester (center foreground). Their guests: an old friend of the family (left) and a new acquaintance (right) from Las Vegas, who was introduced to them as Jimmy, the King of Card Games. Jimmy has just committed an error which looks more like an exercise in cheating than anything else, and everybody is shocked. Most incensed of all is the mother of Theodore and Sylvester, whose thought at this moment is that she should break the bottle of whisky on Jimmy's head or maybe simply throttle him.

pages 112, 113

THE MAN OF DESTINY

A man calling himself Il Duce–the Leader–has appeared on the stage of Italian history. Italy is a little suspicious of him, and so is Garibaldi. The Italians, on the other hand, seem to love this would-be hero who stands on a platform in military uniform and gesticulates dramatically, asking them if they want butter or cannons. Is he going to lead them to glory? Or is he going to lead them to hell?

page 121

THE IDOL

Why is Roberto de Boulet such a success with women? Is it because he is handsome, impeccably dressed, aloof, impervious to womanly charms, linked to romantic adventure…? All Odette St. Agate knows is that she is kneeling languidly at his feet ready to sacrifice her long-preserved chastity to the handsome rogue.

Her best friend, the Vicomtesse de Rougement, tried to warn her. "For God's sake, Odette, stop seeing the man" she said. "He has been married nine times. The money he got through those marriages was lost at roulette in Monte Carlo. What do you think he wants from you? He knows you inherited ninety-five million." Odette was deaf to advice. Wedding bells she wanted, wedding bells she got.

The news of the elopement appeared in all the papers. The management of Monte Carlo added two more tables, one of roulette, one of baccarat, in the Grand Salon. The Vicomtesse de Rougement took things philosophically. "Fiat voluntas Dei," she said in flawless Latin and went back to reading the last chapter of Marcel Proust's *A la recherche….*

pages 126, 127

INCIDENT AT LEXINGTON

This is the start of the action in the American Revolutionary War. At Lexington, Massachusetts, the American patriots, the Minute Men, are for the first time shooting at the red coats. It is the beginning of "a world turned upside down."

pages 129

YORKTOWN VICTORY BANQUET

After the victory at Yorktown and the surrender of Lord Cornwallis, Commander of the British Forces in America, George Washington gives a little party for friends and foes where he introduces an unexpected guest. The Americans welcome her with love while the British are somewhat less than enthusiastic in their salute.

SELECTED BIBLIOGRAPHY

BOOKS AND CATALOGUES:

Rodman, Selden. *The Eye of Man.* New York: Devin Adair, 1955.
Maestri Del '800-'900. Milan: Centro d'Arte, 1972.
I Naifs II. Lugano: Rassegna internazionale delle Arti e della Cultura, 1973.
Artists/USA 1974-75. Philadelphia: Artists/USA Inc.
La Grande Domenica. Exh. cat. Museo La Rotonda di Via Besana, Milan, 1974.
Catalogo Nazionale Bolaffi dei Naifs N.3. Milan: Bolaffi Editore, 1977.
Exh. cat. Musée International D'Art Naïf Anatole Jakovsky, Nice, February, 1982.
Johnson, Jay, and Ketchum, William. *Folk Art of the Twentieth Century.* New York: Rizzoli, 1983.
Camby, Philippe. *Le Paradis et Les Naïfs.* Paris: Max Fourny, 1983.
Les Naïfs Fetent Carnaval. Exh. cat. Musée International D'Art Naïf Anatole Jakovsky, Nice, April, 1984.
Bihalji-Merin, Oto. *World Encyclopedia of Naive Art.* New York: Scala/Philip Wilson, 1984.
Something About the Author, 1985. Detroit: Gale Research Company.
Grumet, Michael. *Images of Liberty.* New York: Arbor House, 1986.
Artist's Palate Cookbook. New Orleans: New Orleans Museum of Art, 1986.
Mermet, Gilles. *La Cité et Les Naïfs.* Paris: Art et Industrie, 1986.

PERIODICALS:

Mormino, Ignazio. "Un Oscar a Milano." *La Notte,* 24 December, 1968.
Buzzati, Dino. "Mostre d'Arte." *Corriere Della Sera,* 17 May, 1971.
Mormino, Ignazio. "Ma chi era Napoleone?" *La Notte,* 17 May, 1971.
Pinosi, Angelo. "Oscar de Mejo ritorna in Italia come pittore." *L'Europeo,* 20 May, 1971.
Leonardi, Ruggero, "Io e Napoleone quasi parenti." *Oggi,* 11 March, 1972.
Patocchi, Aldo. *Illustrazione Ticinese,* 7 May, 1972.
Bortolon, Liana. "Il Cantastorie di Napoleone." *Grazia,* Summer, 1972.
Radius, Emilio. "Per voi dodici naifs." *Grazia,* 28 January, 1973.
Mori, Ermanno. *Il Trottatore,* September, 1983.
Vogel, Al. *M.D,* cover and pp. 158-162, 167, 170-172, January 1984.
Emde, Barbara. *Die Kunst,* pp. 657, 704-709, 737, September, 1985.
Emde, Barbara. "Ein patriotischer erzahler." *Architectural Digest,* June, 1986.
Tucker, George. *Virginian Pilot-Ledger Star,* pp. C1, C3, 9 November, 1986.
Jordan, George E. "Critic's Choice." *Go: Guide to New Orleans,* January, 1987.
Colihan, Jane. "I'd Call This Land Virginia." *American Heritage,* February-March, 1987.
Dispatch-Jamestown Yorktown Foundation Newsletter, "Foundation Receives Gift." Summer, 1987.
Calcano, Isabel Cristina. *Daily Journal,* Caracas, Venezuela. 11 July, 1987.
White, Valerie. "Pawling's Oscar de Mejo: Artist, Author, Composer." *News Chronicle,* Pawling, New York, 9 September, 1987.

Albertazzi, Mario. "La box nobile finisce sulla tela." *Il Progresso*, 25 December, 1987.

Freedman, Diana. "Oscar de Mejo: Dean of Naive Art." *Artspeak*, 16 December, 1987.

McCormack, Ed. "The Wondrous 'Spaghetti Western Surrealism' of Oscar de Mejo." *Artspeak*, 1 December, 1988.

Albertazzi, Mario. "Mostra alla Nahan Gallery." *America Oggi Daily*, 27 December, 1988.

Barigazzi, Giuseppe. "Ora non sono piu' il marito di una diva." *Gente*, 16 February, 1989.

Menozzi, Dino. "Oscar de Mejo alla Nahan Gallery di New York." *L'Arte Naïve*, June, 1989.

BOOKS BY OSCAR DE MEJO:

My America. Preface by Gillo Dorfles. Text by Selden Rodman. New York: Harry N. Abrams, 1982.

Tiny Visitor. New York: Pantheon, 1982.

There's a Hand in the Sky. New York: Pantheon, 1983.

The Forty-niner. New York: Harper & Row, 1985.

Journey to Boc Boc: The Kidnapping of a Rock Star. New York: Harper & Row, 1987.

BOOKS ILLUSTRATED BY OSCAR DE MEJO:

Foley, Paul. *Fresh Views of the American Revolution*. New York: Rizzoli, 1976.

Coerr, Eleanor. *Lady with a Torch*. New York: Harper & Row, 1986.

Marc Gelman. *Does God Have a Big Toe?* New York: Harper & Row, 1989.

Elliott, David. *An Alphabet of Rotten Kids*. New York: Philomel, 1991.

ARTICLES BY OSCAR DE MEJO:

The Yale Literary Magazine Vol. 150, no.4. Cover and pp. 10, 29-44, 89-90.

M.D. "Secrets and Mysteries of Venice." January, 1986.

M.D. "The Miracle of Folk Art." December, 1987.

PUBLICATIONS IN WHICH OSCAR DE MEJO'S PAINTINGS HAVE BEEN REPRODUCED:

Vogue, 1 October, 1953; *Corriere D'Informazione*, 2 March, 1969; *Fly Time*, Summer, 1976; *Franklin Institute News*, Summer, 1976; *L'Arte Naïve*, June, 1981; *American Heritage*, December, 1984; *L'Arte Naïve*, December, 1984; *Ideals Liberty*, December, 1984; *Sciences*, January-February, 1987; *American Heritage of Invention and Technology*, Spring, 1987; *Art Today*, Spring, 1987; *Williamsburg*, October, 1987; *Town & Country*, December, 1987; *Ad Week*, 14 December, 1987; *Sciences*, November-December, 1987; *L'Arte Naïve*, June, 1988; *International Economy*, January-February, 1988; *Menninger Perspective*, No. 2, 1988; *Chicago Tribune Book Magazine*, 14 February, 1988; *Harper's*, May, 1988; *Art & Antiques*, December, 1988; *Town & Country*, December, 1988; *Sciences*, January-February, 1989; *American Heritage*, July-August, 1989; *International Economy*, July-August, 1989; *International Economy*, September-October, 1989.

Juvenilia.1930. These paintings reflect Oscar de Mejo's reading as a boy, in particular H.G. Ewer's *Alraune* and Edgar Alan Poe's *Tales of the Grotesque and Arabesque*.

INDEX TO TITLES OF PAINTINGS